Eyes Right!
A Vintage Postcard Profile of
San Antonio's Military

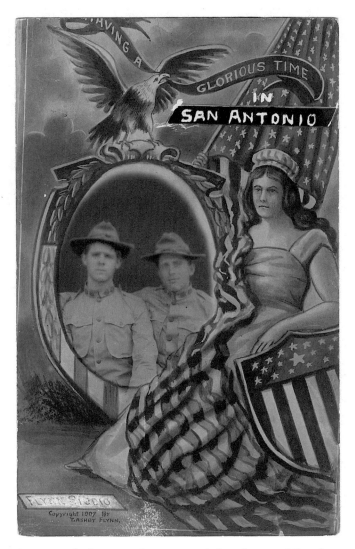

A postcard photographer inserted the photos of Frank Kohila and Callie Mattheu of Fort Sam Houston's 11th Cavalry, G Troop, on a postcard design they could mail home. *(Flynn Studio, 1907)*

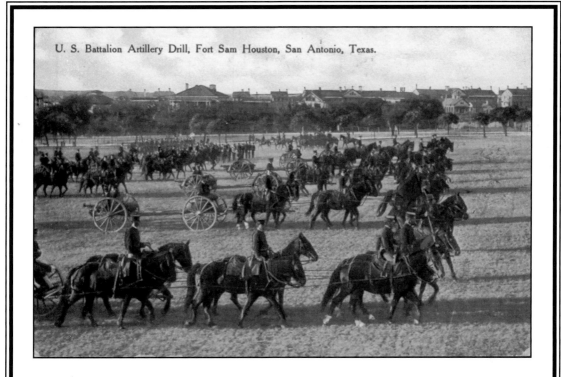

U. S. Battalion Artillery Drill, Fort Sam Houston, San Antonio, Texas.

Eyes Right!

A Vintage Postcard Profile of

San Antonio's Military

Lewis F. Fisher

Maverick Publishing Company

MAVERICK PUBLISHING COMPANY
P.O. Box 6355, San Antonio, Texas 78209

ALSO BY LEWIS F. FISHER

Saving San Antonio: The Precarious Preservation of a Heritage
Crown Jewel of Texas: The Story of San Antonio's River
San Antonio: Outpost of Empires
The Spanish Missions of San Antonio

Library of Congress Cataloging-in-Publication Data

Fisher, Lewis F.
 Eyes Right! : a vintage postcard profile of San Antonio's military / Lewis F. Fisher.
 p. cm.
 Includes bibliographical references.
 ISBN 1-893271-13-7 (alk. paper).
 1. San Antonio (Tex.)—History, Military—20th century—Pictorial works. 2. Postcards—Texas—San Antonio I. Title.
 F394.S21143 F57 2000
 355'.009764'351—dc21

 00-042704

10 09 08 07 06 05 04 03 02 01 00 10 9 8 7 6 5 4 3 2 1

Printed in the United States of America on acid-free paper

ABBREVIATIONS IN CAPTIONS: Postcard publishers' names, when known, appear in italics at the end of each description. "n.p." stands for no publisher identified, "pm." for postmarked.

Contents

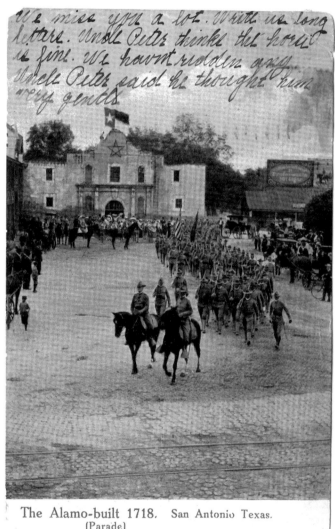

The Alamo-built 1718. San Antonio Texas.
(Parade)

Formations of soldiers were regular features of San
Antonio's early parades, which included an obligatory
pass by the Alamo. *(Chas. Apelt, Comfort, Tex., p m. 1909)*

Why Postcards?

One innovation in communications at the turn of the twentieth century came when printers and filmmakers figured out how to fill the need for large numbers of accurate images of everyday people, places and events that could be easily shared. The breakthrough was picture postcards.

Telephones at the time were not widely used for conversations even across town, and long distance calls were expensive if they could be made at all. Picture postcards offered the double convenience of exchanging brief messages and greetings at half the cost of mailing letters and of sending scenes of home or faraway or of current events—often in color, no less—at a time when newspapers carried very few photographic illustrations.

By the time the meteoric rise of picture postcards was over, they had bequeathed a compelling visual portrait of a fast-changing era.

German printing companies perfected the manufacture of high-quality lithographed postcards. They did work for many American postcard companies, and exported dyes and equipment to others preferring to print postcards themselves.

America's enthusiasm for picture postcards soon matched Europe's. In 1898 privately-printed picture postcards gained the same low postage rate as the U. S. government's own blank postal cards. Handwritten messages were permitted beneath illustrations on the front, and, after a few years, on the back. In 1902 film manufacturers came up with cardstock photographic paper, with preprinted backs, on which photographs could be developed and mailed, proliferating a type known as "real photo" postcards.

The market for postcards of all types mushroomed with the help of rural free delivery, which brought daily mail service to 30 million more Americans. The Post Office Department reported a postcard volume for 1908 of more than 667 million pieces. Five years later the total exceeded 968 million. In 1909 a postcard club based in Philadelphia counted 10,000 members. Postcard manufacturers held annual conventions.

The postcard craze slowed in 1913 in the face of growing popularity of printed greeting cards folded and mailed in

envelopes. It diminished again when access to German printing and supplies was cut off with World War I, and as wider use of telephones filled the need for cross-town communications. Picture postcards moved toward less distinct, white-bordered images by the 1920s and to linen-textured surfaces by the 1940s, on the eve of the modern dominance of glossy color cards.

The "golden era of postcards" left a permanent record of the changing faces of small towns and big cities throughout America. But nowhere did postcards display a greater variety than in portraying popular scenic and faraway places newly accessible by railroad and automobile. Once arrived, visitors usually felt compelled—perhaps with a touch of smugness—to let those back home know where they were.

In 1911 the post office in the resort town of Atlantic City, New Jersey, sold 17 million postage stamps, most for postcards. No doubt a similar use of stamps was being recorded at the same time in San Antonio, Texas, a destination not only for throngs of tourists but also for large numbers of military personnel and recruits in the years preceding, during and between World Wars I and II, and later.

The military has been an integral part of San Antonio since the city's founding in 1718, when a contingent of Spanish soldiers was based at a presidio on Military Plaza. The fall of the Alamo left an indelible military imprint upon the city. By the end of the nineteenth century, the region's favorable climate had helped propel Fort Sam Houston from a supply center for forts on the Indian frontier into a major military training center and supply depot as well, made all the more important by its proximity to unrest on the Mexican side of the Rio Grande. Good flying weather nurtured expansion of military aviation and new training fields.

These nearly 200 vintage postcard images offer a unique profile of the large military presence in San Antonio during the pivotal decades of the early twentieth century. Many are from the collection of Robin Ellis, and many others were gathered by longtime collector Ron Sager. The real photo postcard images in the chapter on the Mexican border are from the collections of the Daughters of the Republic of Texas Library at the Alamo and the Witte Museum. Typical of the historical documentation provided during postcards' golden era, they offer a dramatic and some-times chilling perspective of one crisis, unsettlingly close to home, in which San Antonio's military played an important role.

1. Fort Sam Houston

Annexation of Texas to the United States in 1845 brought the U.S. Army to San Antonio. Three years later the Army turned the Alamo into a quartermaster depot, using it until Post San Antonio was begun on the northern edge of town in 1876. In 1890 the post was renamed in honor of Texas General Sam Houston.

Near the enclosed quadrangle with its stone tower were built separate complexes for infantry and cavalry and artillery soldiers along with rows of fine homes for officers. The grand parade ground, ideal for reviews and practice maneuvers, in 1910 became the site of a pioneer military flight by Lt. Benjamin Foulois in a plane now housed in the National Air and Space Museum.

Continuing growth made Fort Sam Houston by 1940 the nation's largest Army post. Future Allied commanders based here were John J. Pershing on the eve of World War I and, at the outbreak of World War II, Dwight D. Eisenhower.

Among the present tenants are Fifth U.S. Army headquarters, the Health Services Command, the Academy of Health Services and Brooke Army Medical Center. More than 500 acres on post form a National Landmark with 943 historic buildings, many of them shown on the following pages.

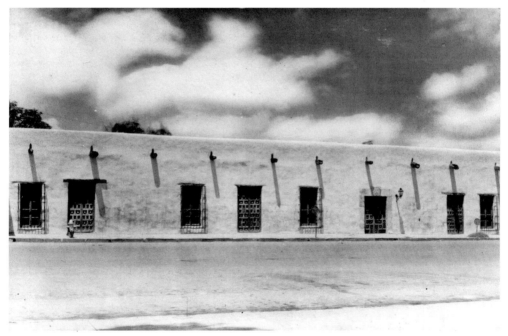

San Antonio's oldest landmark erected for the military is the home built on Military Plaza in 1749 for the captain of the Spanish presidio. Now romantically known as the Spanish Governor's Palace, its restoration was completed in 1931. *(n.p.)*

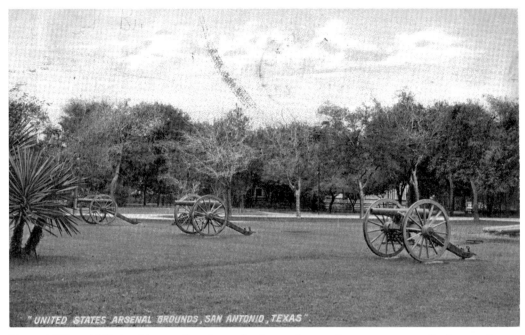

From 1859 to 1949 the 21-acre San Antonio Arsenal near downtown supplied arms for frontier forts, the Confederate Army and both world wars. H-E-B corporate headquarters occupies many of its restored buildings. *(Ebers-White, San Antonio, pm. 1908)*

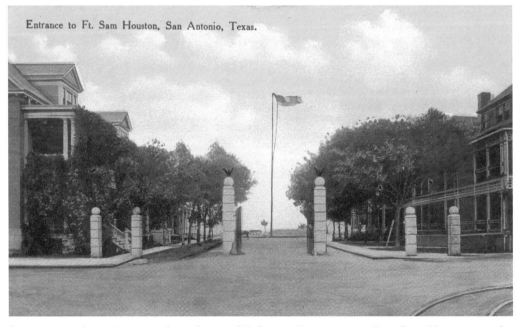

Streetcar tracks swing past the columned Infantry Post entry to Fort Sam Houston at the eastern end of Grayson Street. *(Nic Tengg, San Antonio, pm. 1911)*

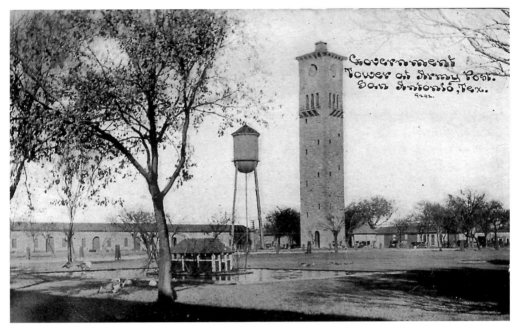

A symbol of Fort Sam Houston is its quadrangle's 90-foot limestone block tower, built to conceal the water tank replaced in 1882 by today's four-faced clock, which strikes every half hour. The steel water tank shown is now gone. *(Sam Rosenthall, San Antonio)*

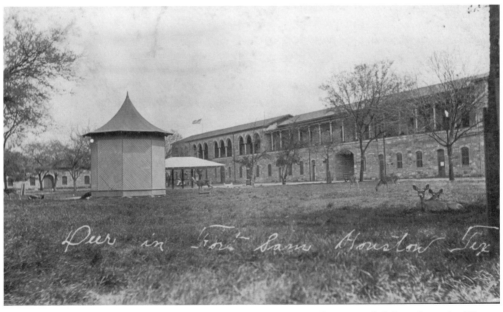

Deer, peacocks, guinea hens and other fowl still roam the peaceful Quadrangle. They mingle with the public and officers and staff members of the Fifth U.S. Army, now headquartered in the surrounding historic buildings. *(n.p.)*

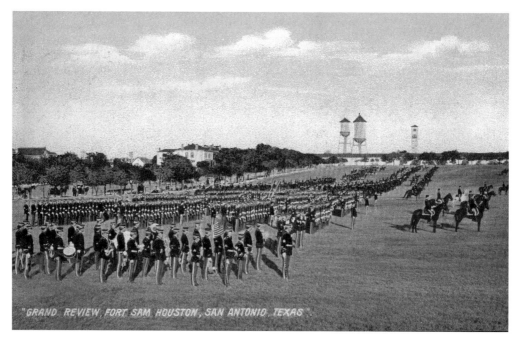

Fort Sam Houston's broad main parade grounds, shown looking southwest with the Quadrangle tower in the background, provided an ideal setting for formal parades. Spectators carriages can be glimpsed under the trees. *(Ebers-White, San Antonio, pm. 1911)*

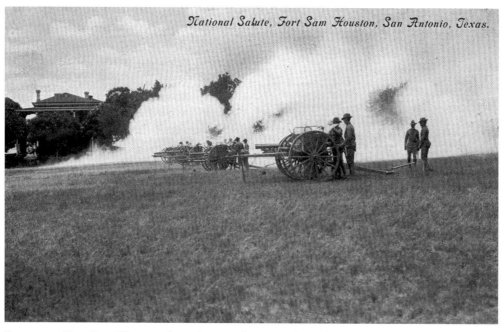

Events on Fort Sam Houston's main parade grounds included the thunderous National Salute, fired simultaneously by several field guns. *(Nic Tengg, San Antonio, pm. 1910)*

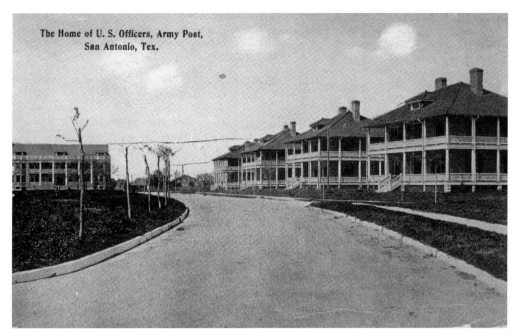

The Home of U. S. Officers, Army Post, San Antonio, Tex.

New Artillery Post officers' homes with their ample verandahs seem to be standing at attention as they stretch in perfect alignment for inspection along the graveled roadway. *(H. Budow, San Antonio, pm. 1916)*

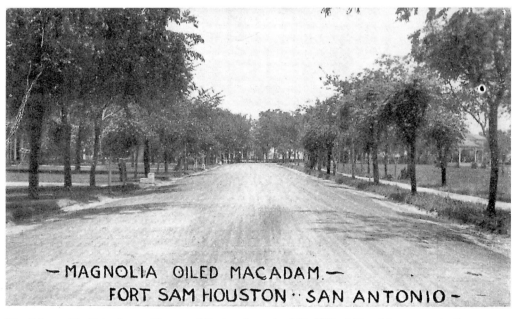

—MAGNOLIA OILED MACADAM.—
FORT SAM HOUSTON · SAN ANTONIO —

The Magnolia Petroleum Co. used its treatment of Staff Post Road to promote the effectiveness of its new oiled macadam as a means of preventing "95% of the dust" common on traditional unpaved roads of the time. *(A. Zeese Engraving Co., Dallas)*

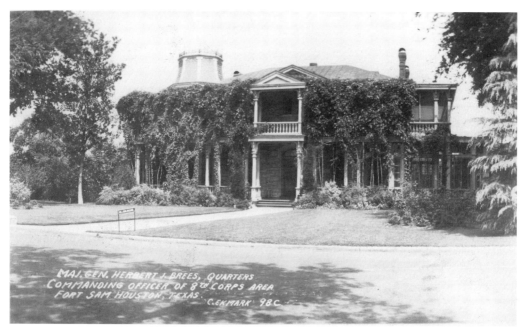

The Army's local highest ranking general traditionally lives in this Staff Post Road home, built in 1881 and known as the Pershing House after Gen. John J. Pershing, who lived here prior to commanding Allied forces in World War I. *(n.p., pm. 1939)*

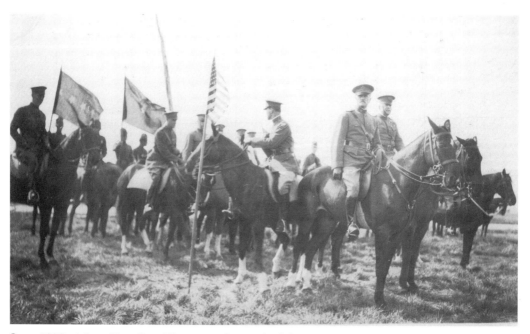

On a 1920 visit to Fort Sam Houston, General of the Armies of the United States John J. Pershing is mounted at right front beside the post's Eighth Corps Area Commander Maj. Gen. Joseph Dickman, who oversaw military installations in six states. *(n.p.)*

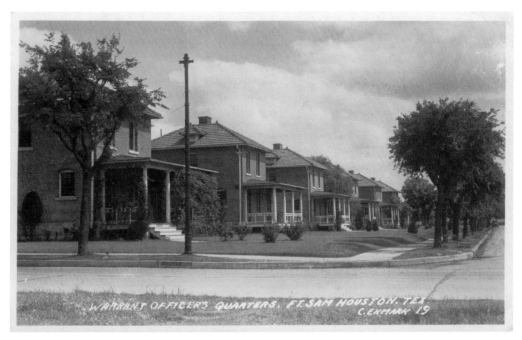

Unlike enlisted personnel, warrant officers got separate quarters, though smaller than those of regular officers. *(n.p., pm. 1942)*

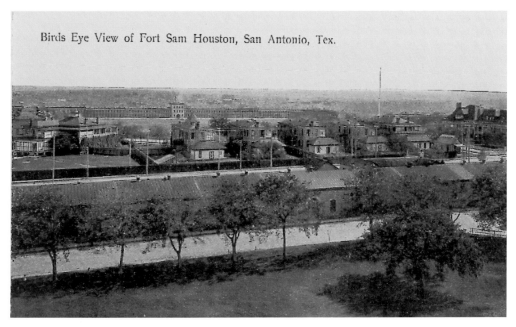

The view of Infantry Post from the clock tower looks over officers' homes and across parade grounds to the long infantry barracks. The large house above left center was once World War II hero Gen. Joseph Stilwell's. *(International Post Card Co., New York)*

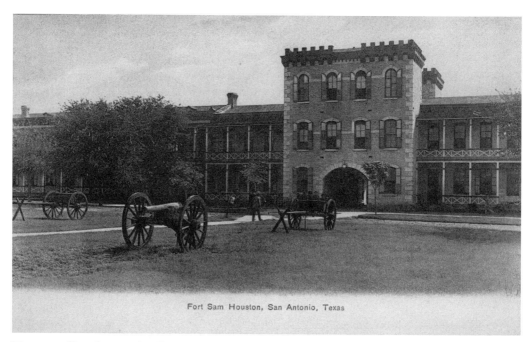

Fort Sam Houston, San Antonio, Texas

The crenellated central sally port section of the 1,000 feet-long Infantry Post barracks was used originally as a military prison. The structure, beside a parade ground, was designed by noted San Antonio architect Alfred Giles. *(St. Louis News Co., St. Louis, Mo.)*

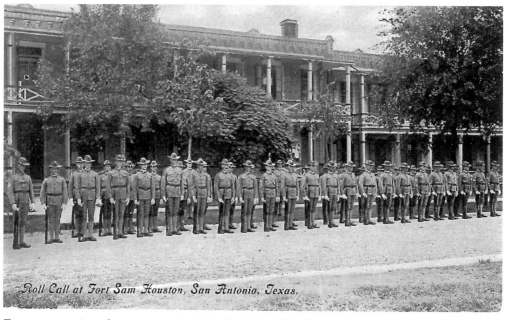

Roll Call at Fort Sam Houston, San Antonio, Texas.

Four companies of troops were originally housed in the two-story brick Infantry Post barracks, built in 1887 and the first permanent barracks at Fort Sam Houston. Its verandahs were enclosed in the 1930s. *(Nic Tengg, San Antonio)*

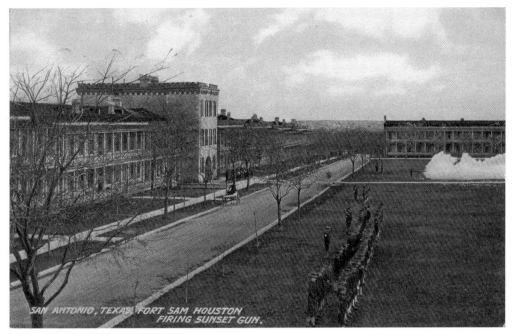

To formally mark the end of the military day, a "sunset gun" was fired on the Infantry Post parade ground. *(Paul Ebers, San Antonio, pm. 1912)*

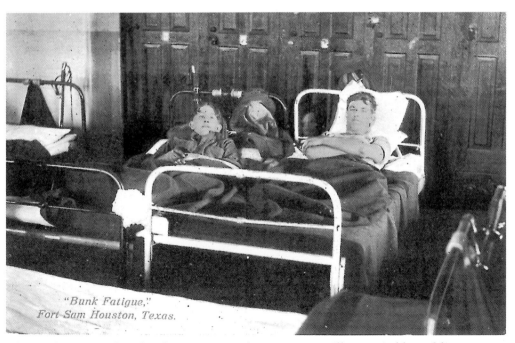

Although surrounding bunks are empty, these two are still occupied by soldiers, diagnosed, at least by the postcard publisher, as suffering from Bunk Fatigue. All bunks have laundry bags hanging from the head bedrail. *(n.p.)*

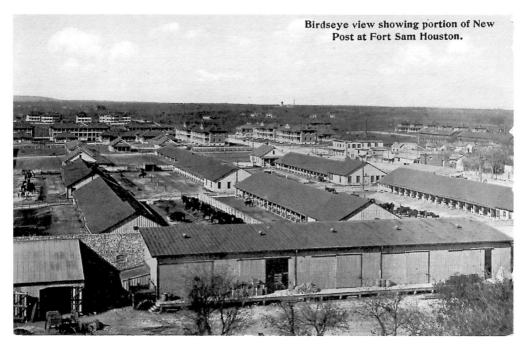

Birdseye view showing portion of New Post at Fort Sam Houston.

A complex of warehouses built along railroad sidings on post after the turn of the twentieth century helped maintain Fort Sam Houston's position as the region's major military supply center. *(Dahrooge Post Card Co., San Antonio)*

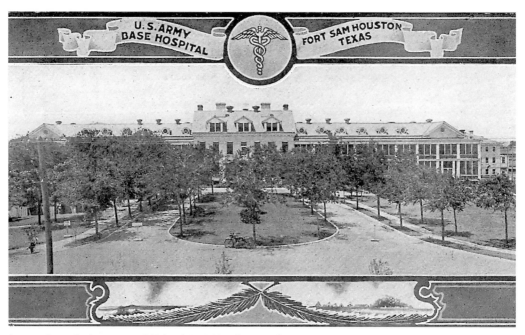

U.S. ARMY BASE HOSPITAL — FORT SAM HOUSTON TEXAS

A post hospital was established in 1881, but its first permanent quarters was this 1908 Artillery Post building. It was enlarged in 1910 and again five years later. *(n.p.)*

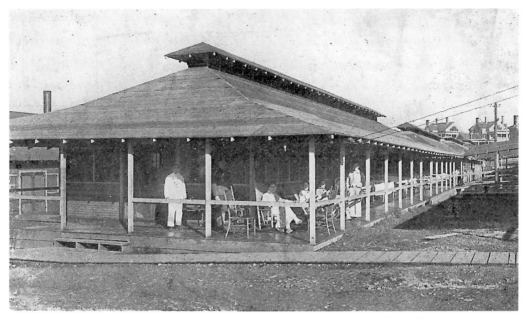

Convalescents were housed in this ward behind the main hospital building, helping increase total capacity to 1,000 beds. *(n.p.)*

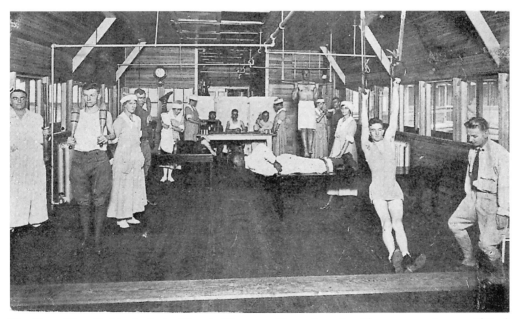

The Base Hospital included a Physio-Therapy Department with a gymnasium outfitted so that during the rigors of physical therapy, as the description on the back of the card reads, "every muscle is brought into play." *(n.p.)*

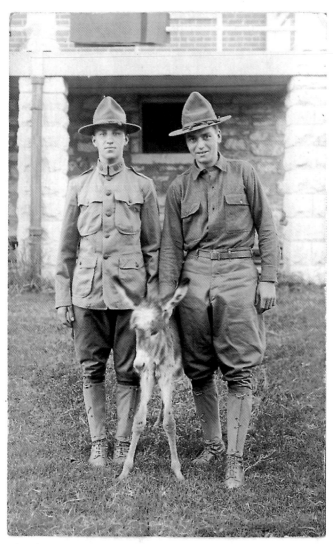

Third U. S. Cavalry soldiers Joseph Schumpf and
Patrick Kelly pose at Fort Sam Houston with the
mascot of C Troop. *(n.p.)*

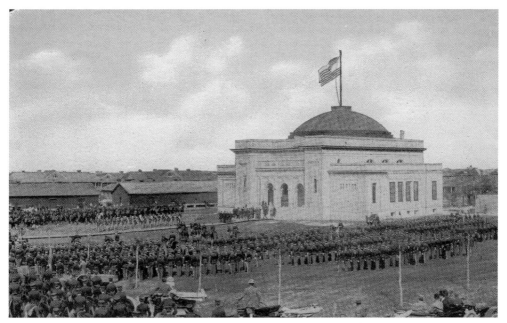

More than 1,000 San Antonians donated funds to build a magnificent post chapel, dedicated by President William Howard Taft in 1909. Inside were placed state flags and the colors of units stationed at Fort Sam Houston. *(Nic Tengg, pm. 1911)*

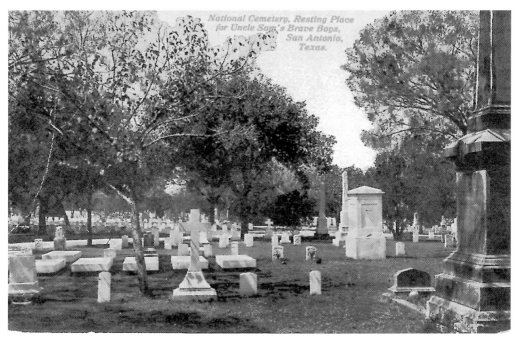

This first National Cemetery near downtown was followed in 1921 by a second, on the former grounds of Camp Travis at Fort Sam Houston, where there are now more than 90,000 graves. *(Dahrooge Co., San Antonio)*

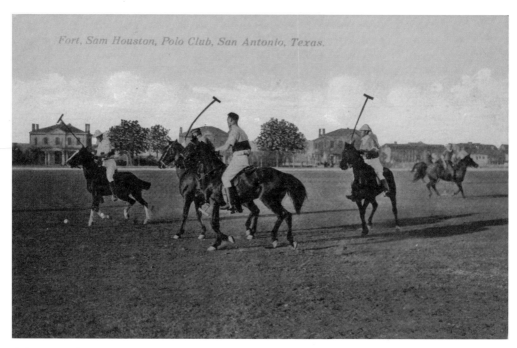

Adept cavalrymen at Fort Sam Houston helped make polo a popular spectator sport in San Antonio. There was a civilian polo field in western Brackenridge Park. *(n.p.)*

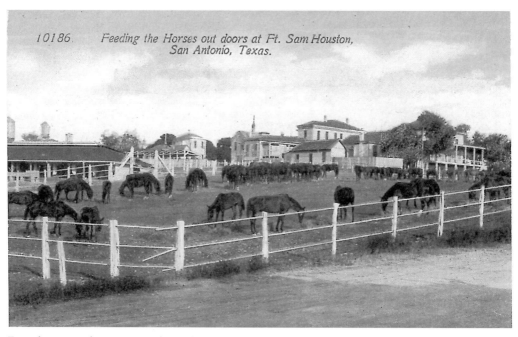

Parade grounds were not the only open spaces at Fort Sam Houston. This slope provided a grazing area for cavalry horses. *(S. H. Kress & Co.)*

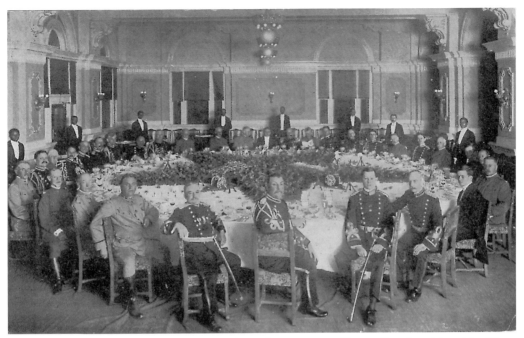

Texas Governor Oscar Colquitt and high-ranking Army officers dined at this table, 75 feet in diameter, at the St. Anthony Hotel about 1912. Haversacks were used as nut holders and the "heavy artillery" was made by the hotel's pastry chef. *(n.p.)*

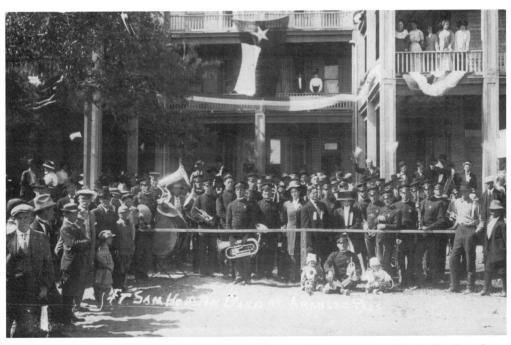

The Army maintained a ceremonial presence beyond San Antonio. This is the Fort Sam Houston Army Band at an event in Aransas Pass on the Texas coast. *(n.p.)*

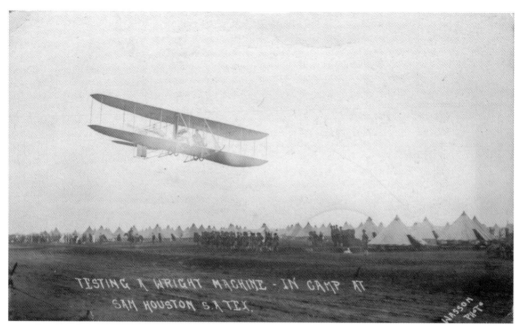

The success of test flights at Fort Sam Houston in 1910–11 under Lt. Benjamin Foulois, whom the Wright brothers taught to fly by mail, led the Army to expand its use of aircraft and establish the 1st Aero Squadron at the post. *(n.p., pm. 1911)*

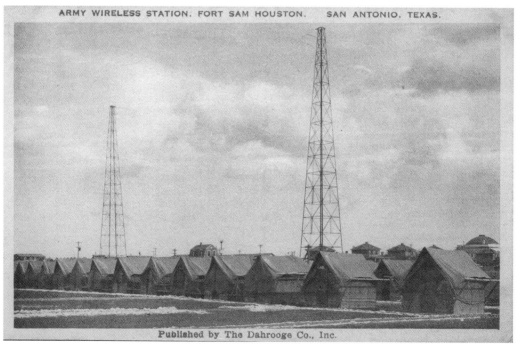

Development of wireless communications soon brought towers to Fort Sam Houston's eastern parade grounds, beside the tents of Camp Wilson. *(Dahrooge Co., San Antonio, pm. 1914)*

The post's mansard-roofed wireless station was built between the twin antenna towers, from which wires could be conveniently strung and connected to receivers and transmitters indoors. *(n.p.)*

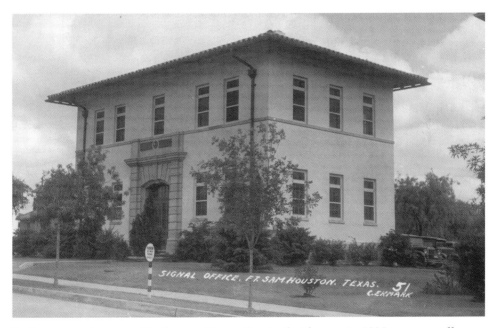

In the expansion over the former Camp Travis that began in 1928, even smaller buildings kept the integrity of the stylish Spanish Colonial Revival architecture with their tile roofs and elegant entrances. *(n.p.)*

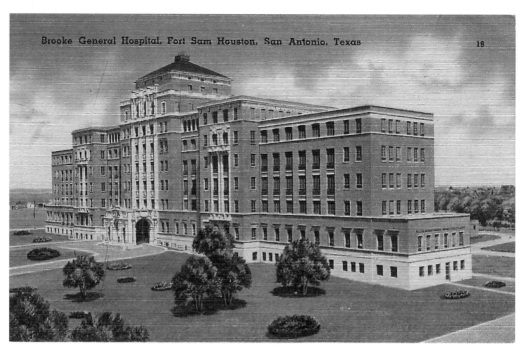

Brooke General Hospital opened on February 7, 1938. Adjoining structures stretched capacity to 10,000 during World War II, and its world-famous burn center was added in 1949. A replacement complex opened nearby in 1994. *(San Antonio Post Card Co.)*

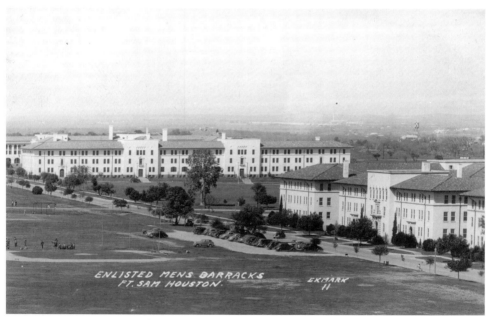

The Spanish Colonial Revival style enlisted mens' barracks at the left were later remodeled as Brooke Army Medical Center's Beach Pavilion. *(n.p.)*

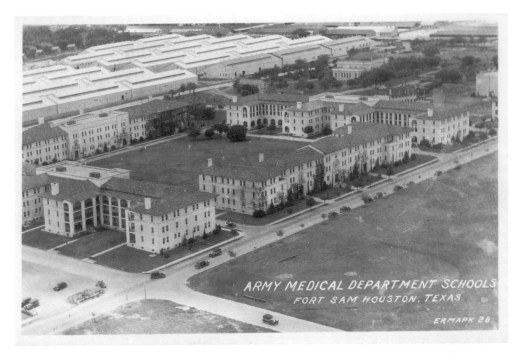

Army medical training has since expanded beyond this 1930s complex into the new Academy of Health Services. *(n.p.)*

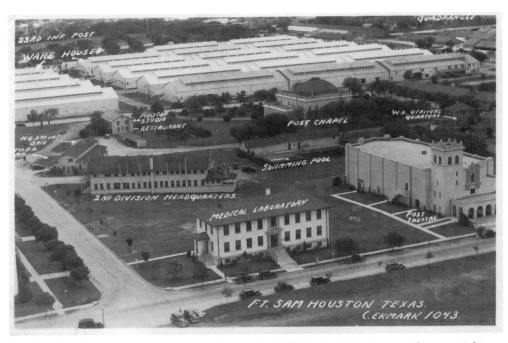

New construction at Fort Sam Houston in the 1930s included the post theater, right, with its landmark mission-style tower. *(n.p.)*

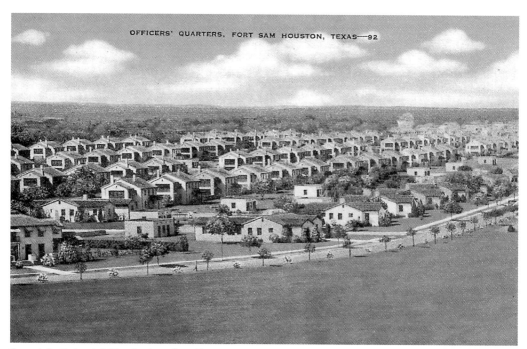

OFFICERS' QUARTERS, FORT SAM HOUSTON, TEXAS—92

Spanish Colonial Revival style officers' quarters with red tile roofs spread past the northern edge of the eastern parade grounds. *(Post Photo Shop, San Antonio)*

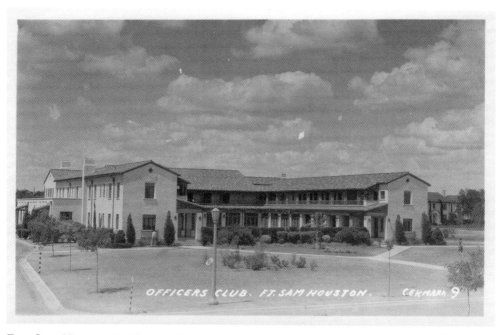

Fort Sam Houston's Officers' Club as it appeared when nearly new in the 1930s. *(n.p.)*

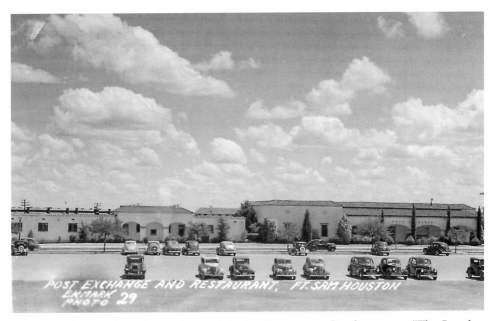

San Antonio may have been the mythical military paradise known as "The Land of the Big PX," judging from this elegant facility built at Fort Sam Houston in the 1930s. *(n.p.)*

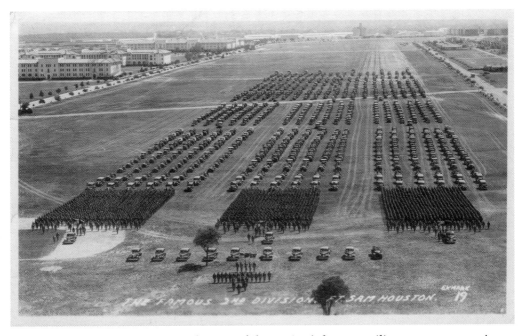

In 1937 Fort Sam Houston was the site of the nation's largest military maneuvers since World War I. *(n.p.)*

We have crossed the ocean mid the dangers of the foes, submarines. We have fought .in the trenches with our Allies, in foreign lands; we have gone over the top, and brought victory to our country.

We have left our comrades on the battlefields of Sunny France; a living monument to the chivalry and the bravery of the boys of the U. S. A.

And now we are gathered together 'neath the shadow of the Alamo, in the playground of America at San Antonio, Texas,

To partake of the hospitality of the South, in convention assembled, in our endeavor to hold together the remnants of the great legion of the brave that must never die.

R. G. SCOTT

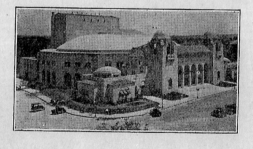

This postcard for the American Legion convention in San Antonio in 1928 shows Municipal Auditorium, built to honor those who served in World War I. (n.p.)

2. Camp Wilson and Beyond

Mexican Revolutionary Pancho Villa's raid on Columbus, New Mexico, in 1916 electrified the nation. National Guard troops were quickly mobilized to forts near the border. Some 13,000 Guardsmen were set up on the then-northeast border of Fort Sam Houston in a tent city enlarged and called Camp Wilson, where Regular Army troops gave the reservists intensive training. World War I soon caused Camp Wilson to be expanded and renamed Camp Travis.

San Antonio's sunny climate made the region ideal for such training. Troops made frequent marches into the surrounding countryside, sometimes camping near Hot Wells on the city's south side or practicing pontoon bridge building and crossings at West End Lake, later Woodlawn Lake, on the west side.

A prime destination was 20 miles northwest of San Antonio out Military Highway and Fredericksburg Road—the Leon Springs Military Reservation, by World War I covering some 20,000 acres. An officer training school named Camp Funston was established there in 1917. The reservation now encompasses Camp Stanley, used for ammunition storage and testing, and Camp Bullis, used for firing ranges, combat training and medical field training.

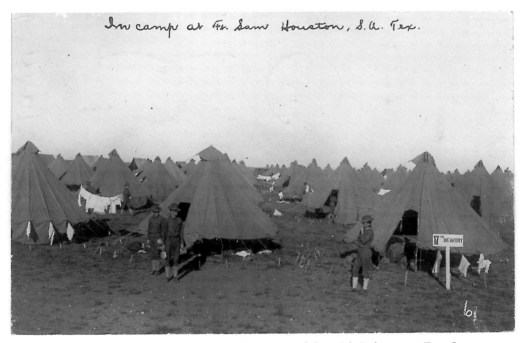

Laundry lines were interspersed among the tents of the 17th Infantry at Fort Sam Houston's Camp Wilson. *(n.p., pm. 1911)*

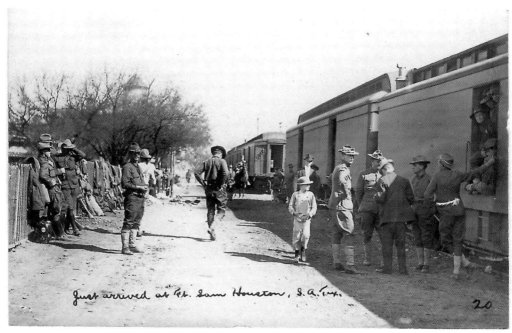

Just arrived at Ft. Sam Houston, S. A. Tex.

20

Railroad sidings near Fort Sam Houston proved quite advantageous in moving troops. *(n.p.)*

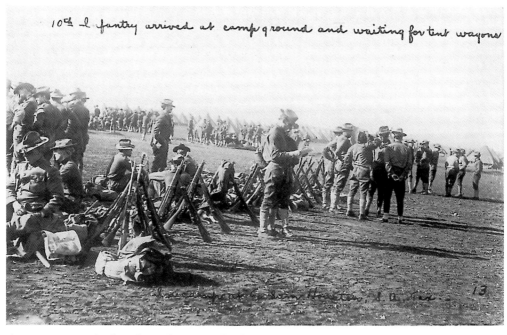

10th Infantry arrived at camp ground and waiting for tent wagons

13

Arms were stacked and newly-arrived soldiers on maneuvers relaxed while awaiting arrival of wagons with their tents. *(n.p.)*

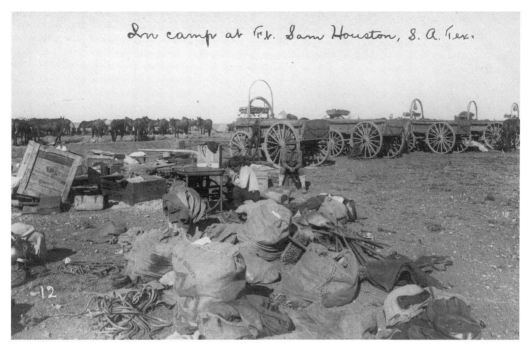

In camp at Ft. Sam Houston, S. A. Tex.

Horses and mules try grazing on the hard ground at Camp Wilson after their wagons were unloaded. *(n.p.)*

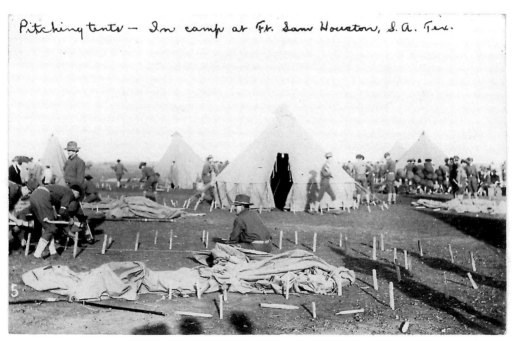

Pitching tents — In camp at Ft. Sam Houston, S. A. Tex.

Pitching conical tents required first driving a precise circular layout of stakes into the ground. *(n.p.)*

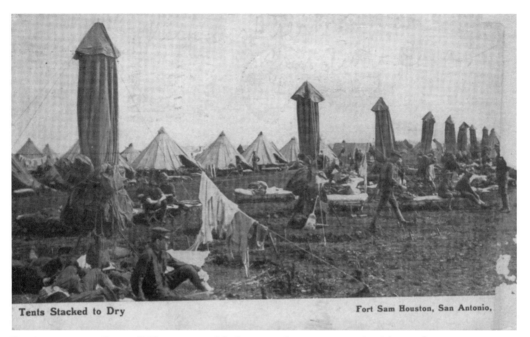

Tents Stacked to Dry Fort Sam Houston, San Antonio,

Drying tents at Camp Wilson resembled rows of saguaro cacti without the arms. *(C. O. Lee, San Antonio, pm. 1911)*

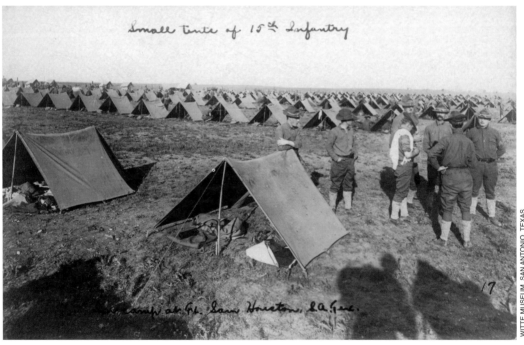

The 15th Infantry's pup tents could be pitched quickly. *(n.p.)*

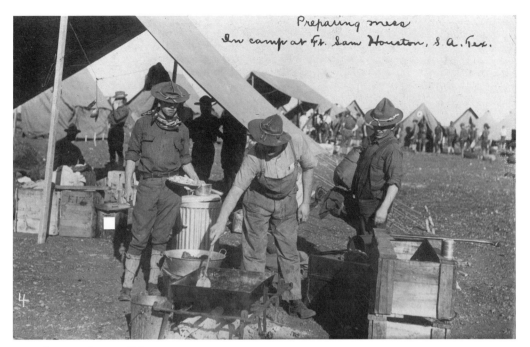

K.P. duty at Camp Wilson. *(n.p.)*

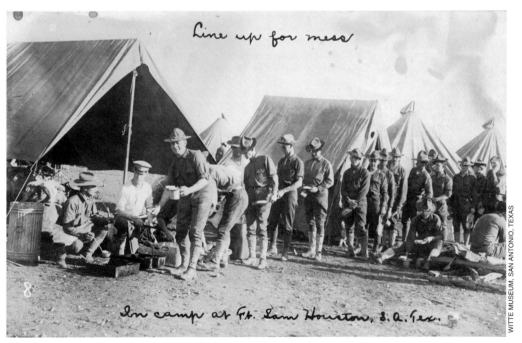

Mealtime was presumably one of the more pleasant reasons for standing in line. *(n.p.)*

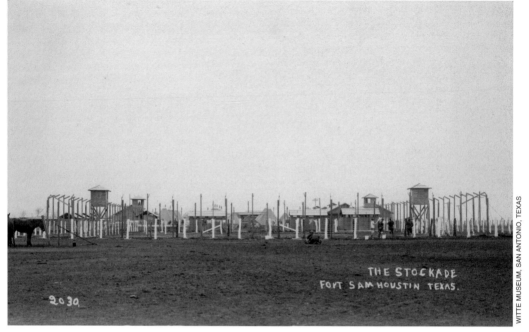

Watchtowers inside the four corners of the barbed wire stockade helped guards keep an eye on those within. *(n.p.)*

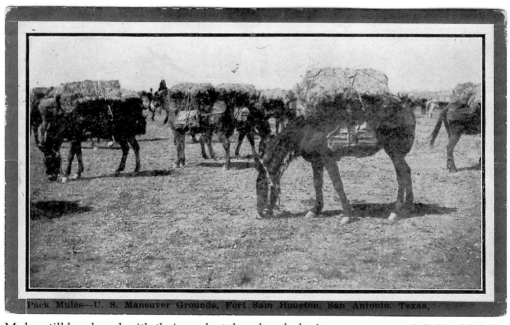

Mules still burdened with their packs take a break during maneuvers. *(J. R. Wood Printing Co., San Antonio, pm. 1911)*

Which is which? is an apparent point of the message on this postcard portrait. *(H. Budow, San Antonio)*

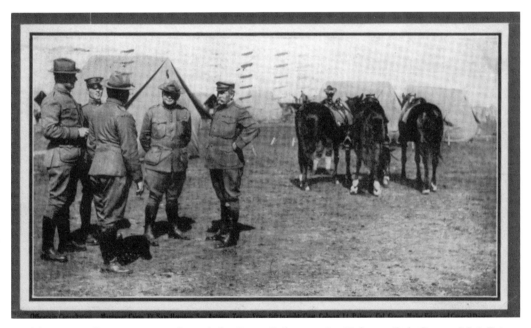

Holding a staff meeting are, from left, Capt. Coleman, Lt. Palmer, Col. Green, Maj. Friar and Gen. Duncan. *(J. R. Wood Printing Co., San Antonio, pm. 1911)*

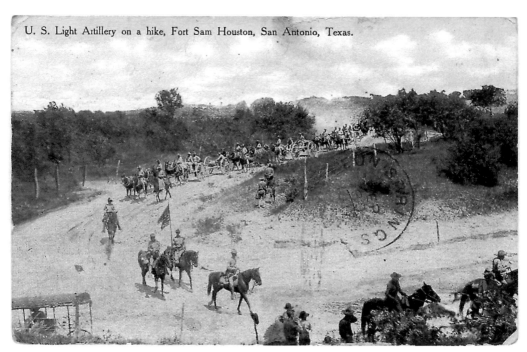

U. S. Light Artillery on a hike, Fort Sam Houston, San Antonio, Texas.

Frequent training maneuvers took troops and artillery down the unpaved roads through the ranch lands that stretched in all directions from San Antonio. *(Nic Tengg, San Antonio, pm. 1910)*

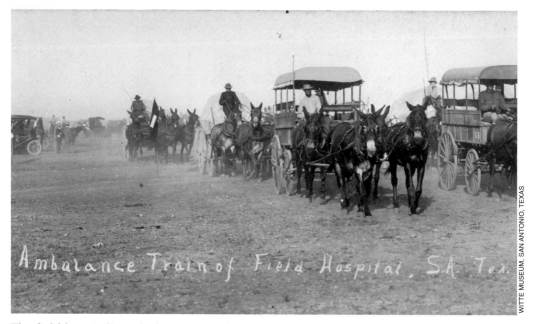

Ambulance Train of Field Hospital, S.A. Tex.

The field hospital's ambulance train also went on maneuvers. *(n.p.)*

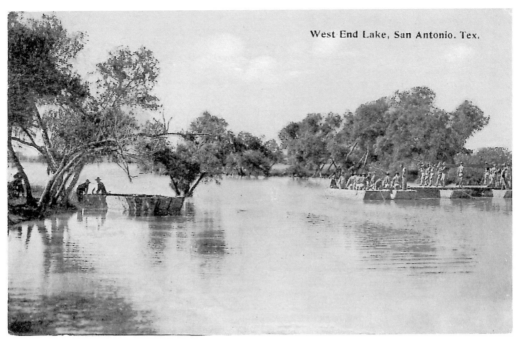

Building pontoon bridges was practiced at West End Lake, later Woodlawn Lake, a new development on the then-western edge of San Antonio. *(H. Budow, San Antonio)*

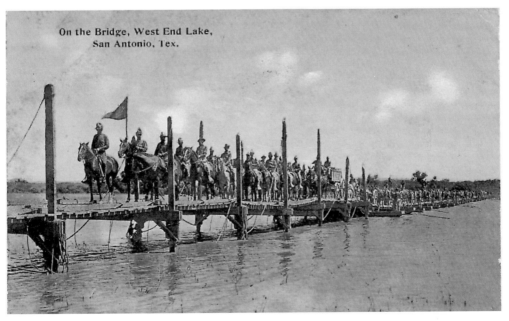

Training for crossing newly-completed pontoon bridges on horseback was also provided at West End Lake. *(H. Budow, San Antonio)*

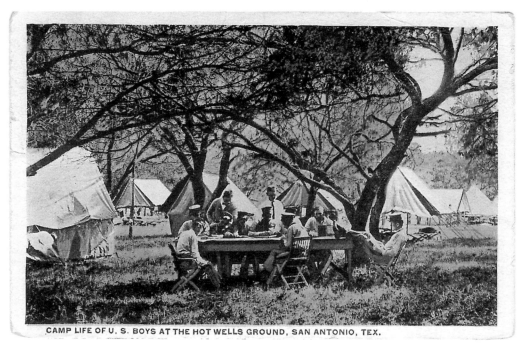

CAMP LIFE OF U. S. BOYS AT THE HOT WELLS GROUND, SAN ANTONIO, TEX.

One destination for troops on maneuvers was a camp area south of San Antonio near Hot Wells. *(Dahrooge Co., San Antonio)*

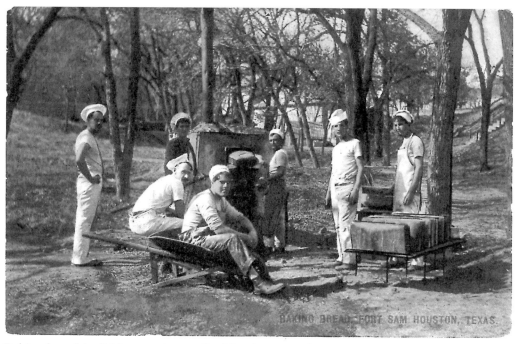

BAKING BREAD, FORT SAM HOUSTON, TEXAS.

Baking bread in field ovens is practiced by Army cooks. *(n.p.)*

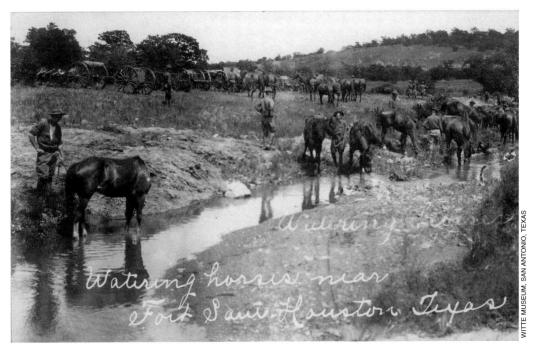

Lack of motorized vehicles meant a different sort of refueling stop. *(n.p.)*

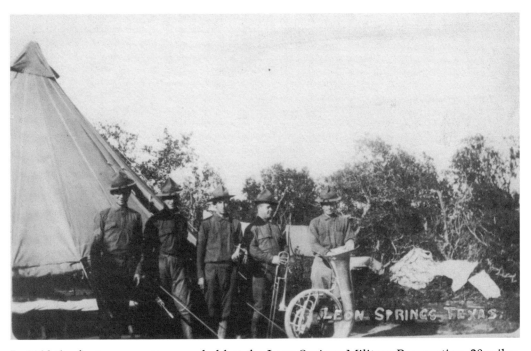

In 1908 the first maneuvers were held at the Leon Springs Military Reservation, 20 miles northwest of Fort Sam Houston, which now comprises camps Stanley and Bullis. *(n.p., pm. 1913)*

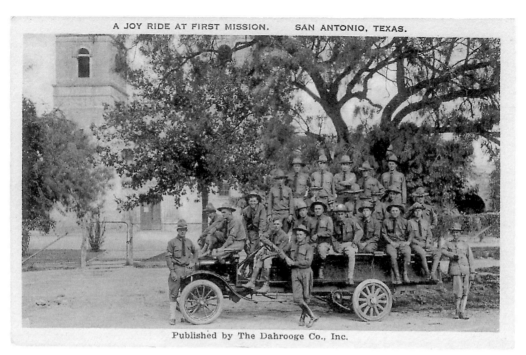

Published by The Dahrooge Co., Inc.

Soldiers in their spare time could take in the local sights, which included Mission Concepción, the first of San Antonio's Spanish missions reached from downtown San Antonio. *(Dahrooge Co., San Antonio.)*

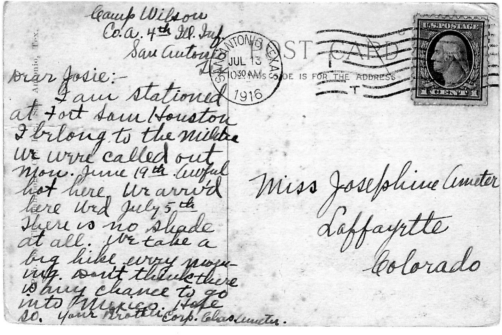

Postcards also offer the opportunity to read other people's mail. Here's what Corp. Charles Ameter, a Texas National Guardsman called to Camp Wilson during the Mexican border crisis, had to say to his sister in Colorado.

3. The U. S. Army vs. Pancho Villa on the Mexican Border

When Francisco "Pancho" Villa, leader of one of the Mexican Revolution factions that had kept that nation in turmoil since 1910, saw another faction recognized by the United States he sought to stir up trouble. In March 1916 Villa led a raid on Columbus, New Mexico, some 60 miles west of El Paso. It left more than a dozen Americans dead. U. S. Army General John J. Pershing was posted to El Paso with orders to bring Villa to heel.

As more than 10,000 U. S. troops moved to the border, Texas National Guard units were mobilized and sent to Fort Sam Houston's Camp Wilson for training. Eight of the nine airplanes of the 1st Aero Squadron, based at the post, were crated, sent by train to the border and reassembled for warfare's first aerial reconnaissance. The post was upgraded to general depot status to supply the border forces. Although Villa was never captured, his troops were scattered in a battle at Torreon in January 1917 and the punitive expedition, which happened to provide valuable training for World War I, ended.

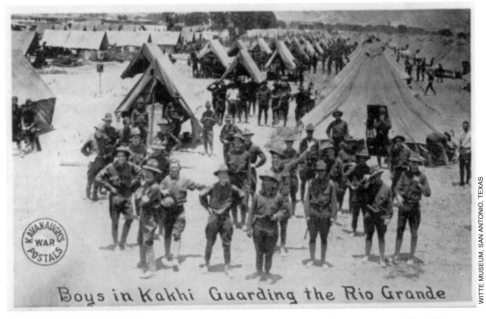

U. S. Army camps dotted the Rio Grande country, like this one published by prolific postcard producer E. J. Kavanaugh of Chicago and El Paso.

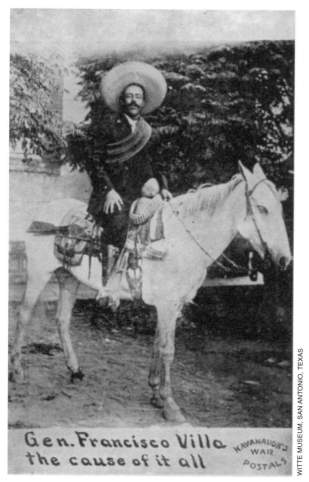

The U. S. Army's target in Mexico was the legendary and elusive revolutionary Francisco "Pancho" Villa, shown in full regalia.

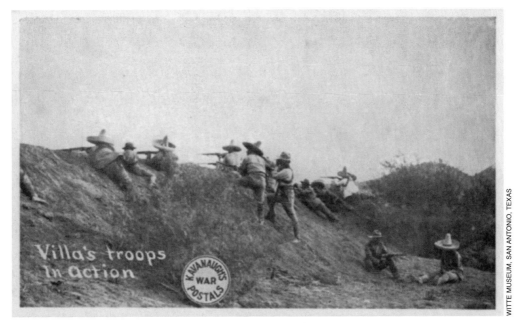

Scenes from the other side made popular subjects for postcard companies eager to provide soldiers with war images to send back home, where newspapers usually were still technically unable to print such scenes.

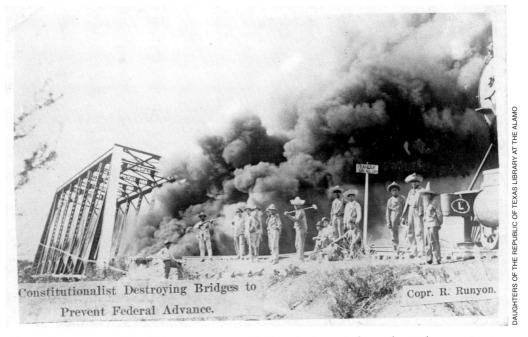

Mexico's transportation infrastructure was being destroyed throughout the country by one revolutionary faction or another.

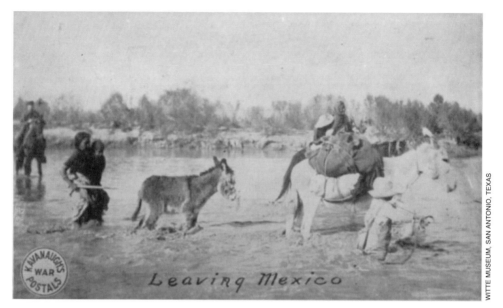

Several hundred thousand civilian refugees fled the revolution in Mexico and crossed into the United States, many never to return. Tens of thousands crowded into San Antonio, with profound implications for the city's future.

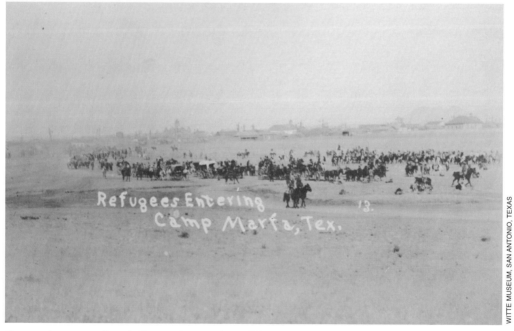

One major camp for civilian refugees from Mexico was set up at Marfa, in Big Bend country some 50 miles from the Rio Grande and 250 miles west of San Antonio.

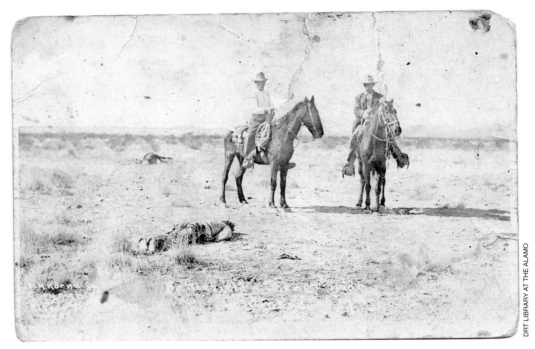

Lone revolutionaries referred to as "bandits" wreaked havoc in the countryside and were often hunted down by their fellow Mexicans. This one made it only a short distance after bullets apparently meant for him first felled his horse.

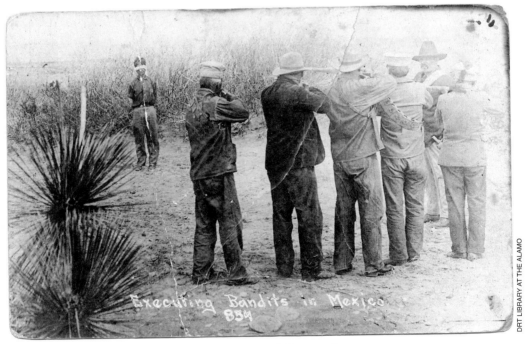

This "bandit" was caught first, then given quick "justice."

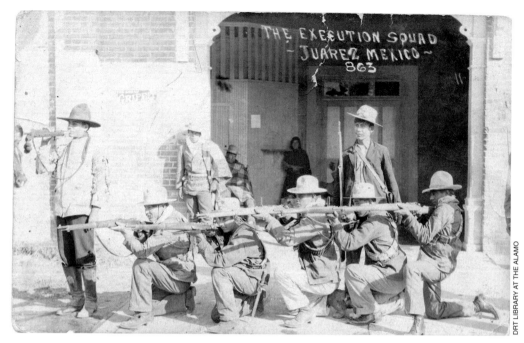

Executions across the border could be ceremonial events.

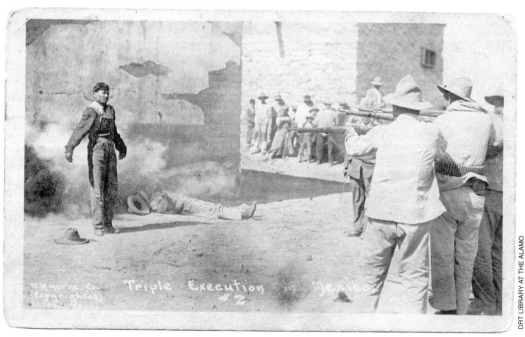

The last moments of Juan Aguilar, one of three revolutionaries executed at the railroad station in Ciudad Juárez on January 15, 1916, were caught by accomplished postcard photographer and publisher Walter H. Horne of El Paso, just across the border.

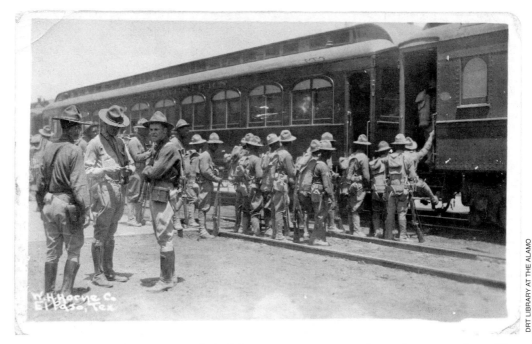

A good national rail system was helpful in moving troops and supplies from places like San Antonio to the Mexican border.

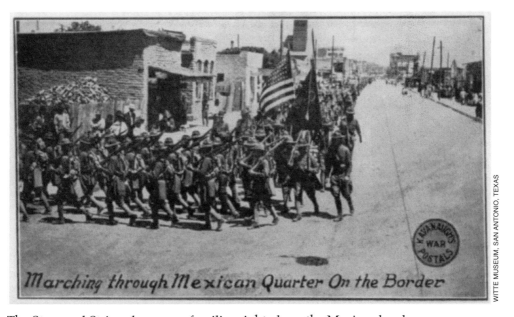

Marching through Mexican Quarter On the Border

The Stars and Stripes became a familiar sight along the Mexican border.

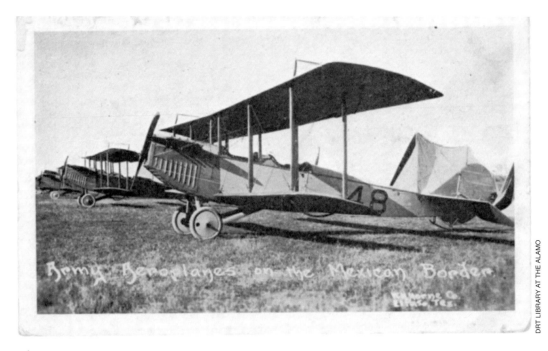

The 1st Aero Squadron's American-made Curtiss "Jennies" were crated and sent by train from Fort Sam Houston to the Mexican border, where they were reassembled and used in the first wartime aerial reconnaissance efforts.

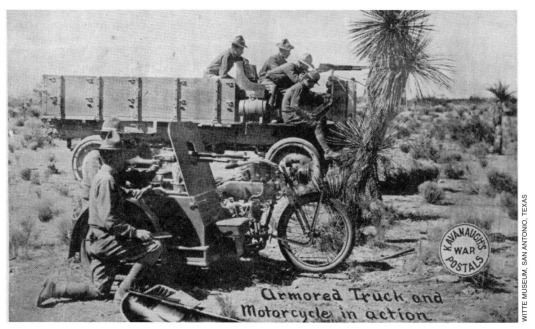

Machine guns mounted on newly-armored trucks and even on motorcycles turned out to be of limited use, since bumpy roads usually caused the guns to miss their marks if fired when the host vehicle was in motion.

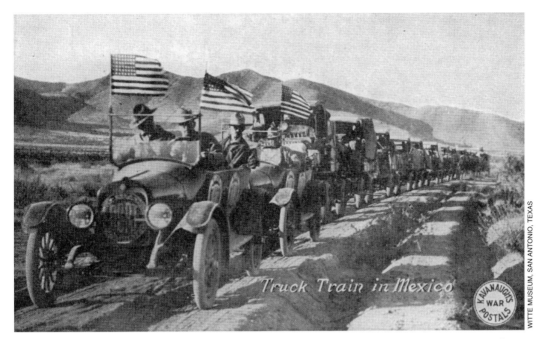

Motorized trucks were useful in moving supplies over prepared roadways, but on other roads bogged down in mud and could not keep up with the maneuverability of Pancho Villa's forces.

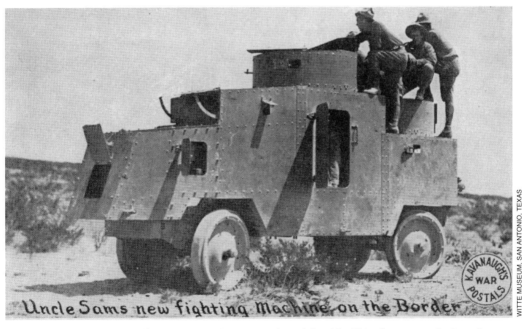

The U. S. Army's four-wheel drive Jeffrey Quad tank had half-inch armor plating. It carried two machine guns and a six-man crew.

The U. S. Army vs. Pancho Villa 43

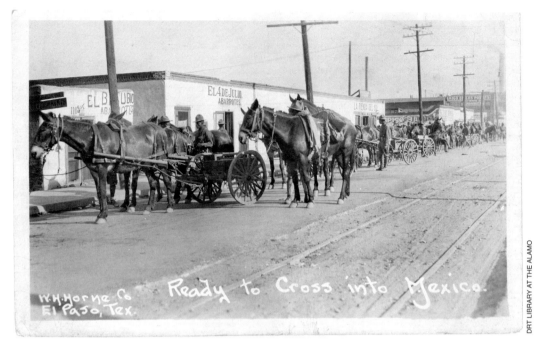

In this transitional era, horse drawn and mule drawn wagons stilled played an important role in U. S. Army operations.

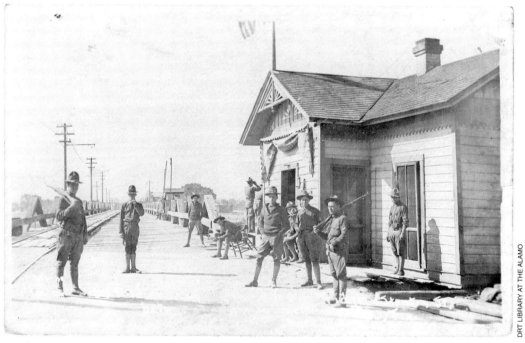

Bridges were key points to be protected from raids by Villa's fast-moving troops.

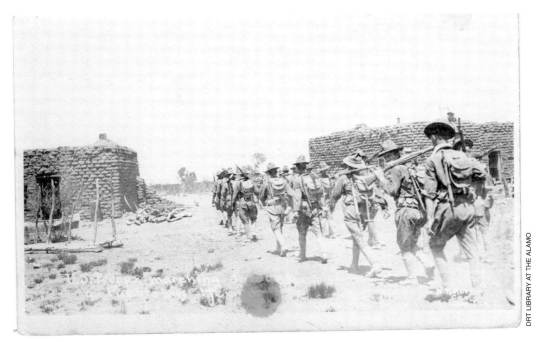

Springfield rifles, bayonets, canteens and machetes were carried along with backpacks full of supplies by soldiers scouring the countryside.

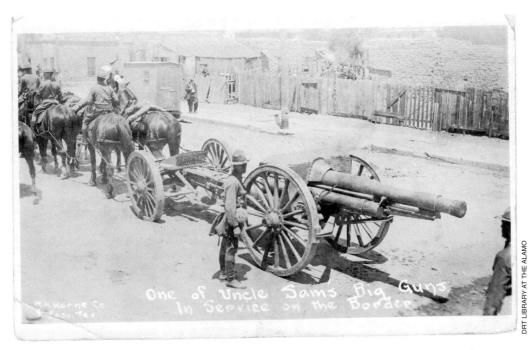

U. S. Army field guns passing through border villages made an intimidating sight.

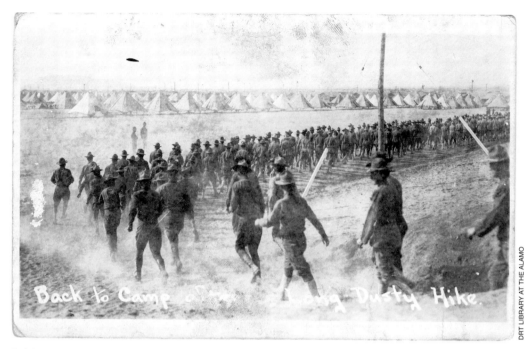

Soldiers' steps seemed to pick up as they neared camp after a long march.

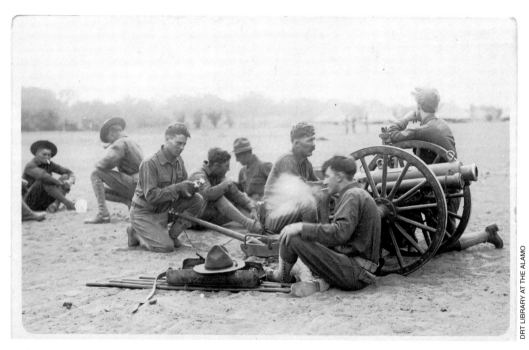

Relaxing back in camp gave this artillery crew time for a smoke.

4. A Recruit's Life at Camp Travis

Once the United States entered World War I, Fort Sam Houston's Camp Wilson, already set up to train two regiments, was an easy choice for expansion to train an entire division. It was enlarged to more than 18,000 acres, a complex of temporary wooden buildings was quickly erected on 800 acres and the site was renamed Camp Travis in honor of Alamo hero William Barret Travis.

In August 1917 Camp Travis was ready to turn the more than 31,000 officers and men arriving from Texas and Oklahoma into the new 90th Division. The following August, Camp Travis commander Maj. Gen. Henry T. Allen took the force—often known as the Alamo Division—to the front lines in France, where the allied commander, Gen. John J. Pershing, rated it one of the Army's top six divisions overseas.

After the 90th left, Camp Travis's numerical strength was maintained with recruits for a new division, the 18th, its training unfinished when the war ended in November 1918. Camp Travis then became a demobilization processing center for 62,500 troops. In 1922 it was absorbed by Fort Sam Houston. Most of its buildings, deserted and deteriorating, were torn down by 1928.

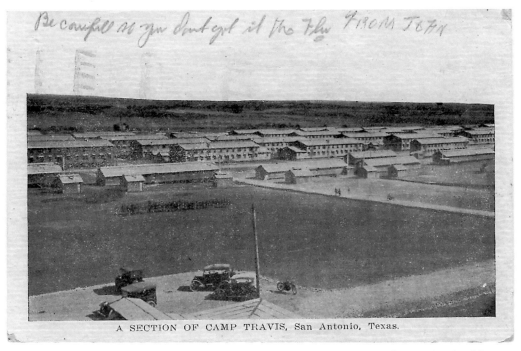

A SECTION OF CAMP TRAVIS, San Antonio, Texas.

Some 800 acres of land at Fort Sam Houston were quickly filled with wooden buildings for Camp Travis as World War I approached. (*A. M. Simon, New York, pm. 1919*)

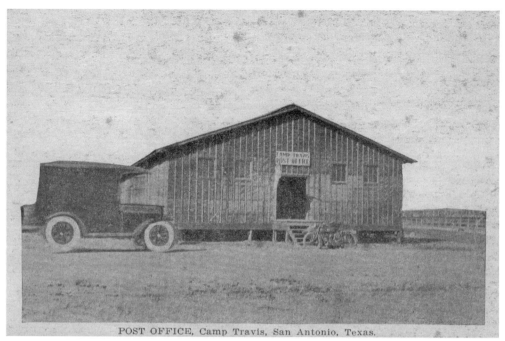

POST OFFICE, Camp Travis, San Antonio, Texas.

One of the most popular spots on Camp Travis was the post office, where trainees could pick up word from home. (*A. M. Simon, New York*)

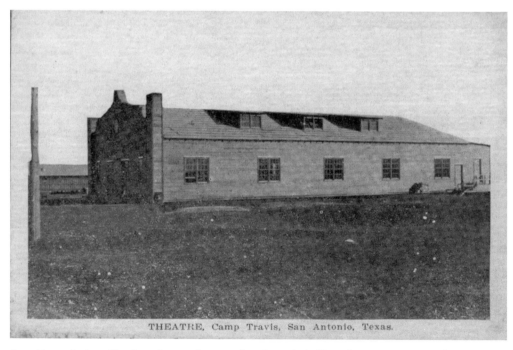

THEATRE, Camp Travis, San Antonio, Texas.

An attempt at replicating the exuberant facades of civilian theaters was made in constructing Camp Travis's frame theater. (*A. M. Simon, New York*)

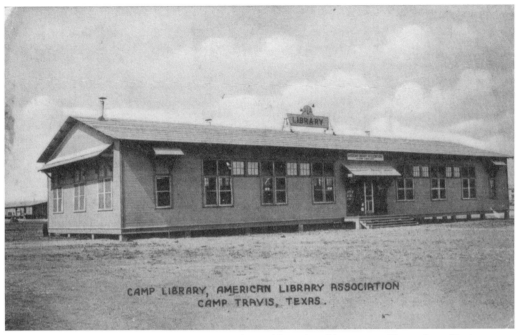

CAMP LIBRARY, AMERICAN LIBRARY ASSOCIATION
CAMP TRAVIS, TEXAS.

Among the agencies building structures for soldiers' welfare on military installations was the American Library Association. *(n.p.)*

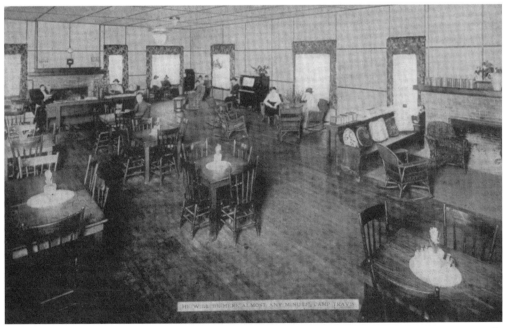

Wicker rockers around the hearth helped the YWCA Hostess House convey a sense of hominess to lonely soldiers at Camp Travis. *(n.p.)*

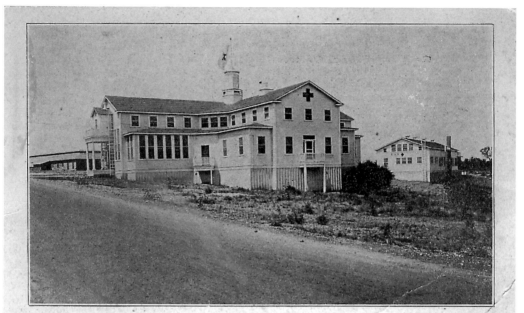

RED CROSS HOUSE AND NURSES' HOUSE—CAMP TRAVIS HOSPITAL, SAN ANTONIO, TEXAS

Camp Travis had its own hospital, separate from the Fort Sam Houston post facility. (*n.p.*)

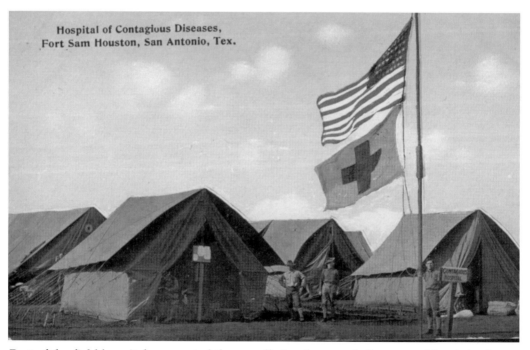

Hospital of Contagious Diseases,
Fort Sam Houston, San Antonio, Tex.

Part of the field hospital segregated those suffering from an influenza epidemic in the fall of 1918. More than 11,000 recruits came down with the disease, and 201 died. All of Camp Travis was quarantined for a month. (*H. Budow, San Antonio*)

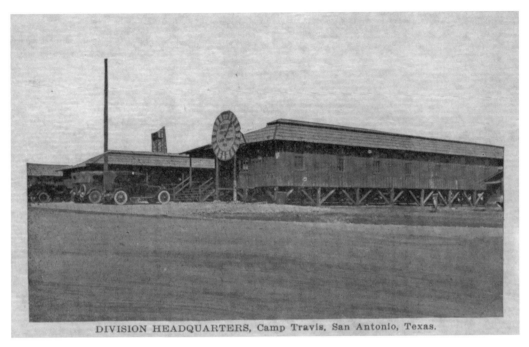

DIVISION HEADQUARTERS, Camp Travis, San Antonio, Texas.

90th Division Headquarters was the nerve center for Camp Travis. *(A. M. Simon, New York)*

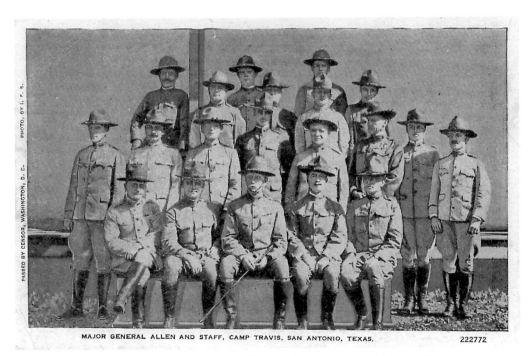

MAJOR GENERAL ALLEN AND STAFF, CAMP TRAVIS, SAN ANTONIO, TEXAS. 222772

Although at age 58 Maj. Gen. Henry T. Allen, at front center with his riding crop, was older than most American combat commanders, he was still picked to take the 90th Division overseas, and performed admirably. *(Sackett & Williams Co., New York, p m. 1918)*

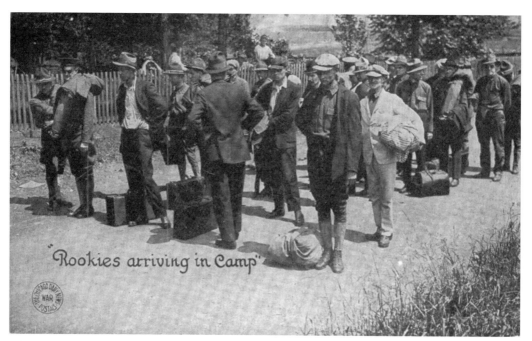

Thousands of recruits from Texas and Oklahoma arrived at Camp Travis to form the 90th Division and, after its departure for France, the 18th Division. *(Chicago Daily News, War Postal Card Dept.)*

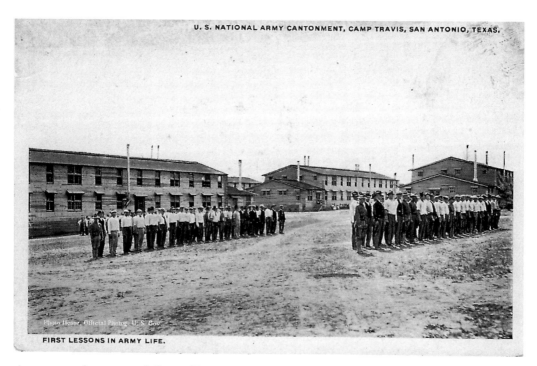

As soon as they entered Camp Travis, new arrivals were put in a semblance of military alignment. *(Nic Tengg, San Antonio)*

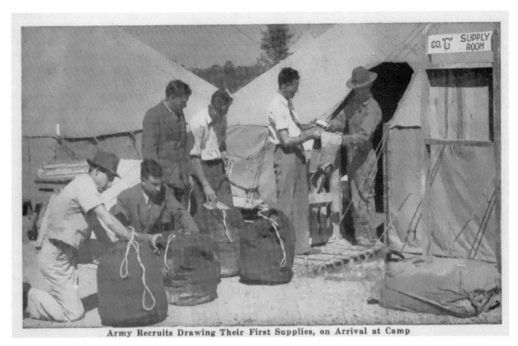

Army Recruits Drawing Their First Supplies, on Arrival at Camp

The company supply room was an early stop. *(Graycraft Card Co., Danville, Va.)*

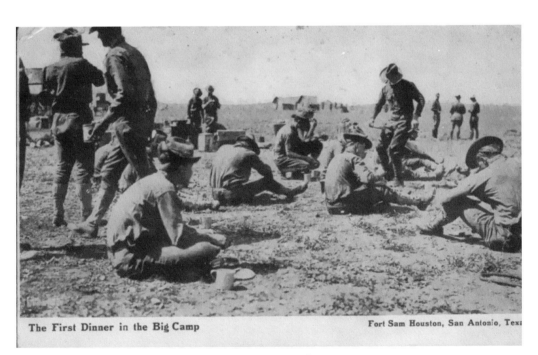

The First Dinner in the Big Camp Fort Sam Houston, San Antonio, Tex;

Once in uniform, recruits dined like soldiers near the front. *(C. O. Lee, San Antonio)*

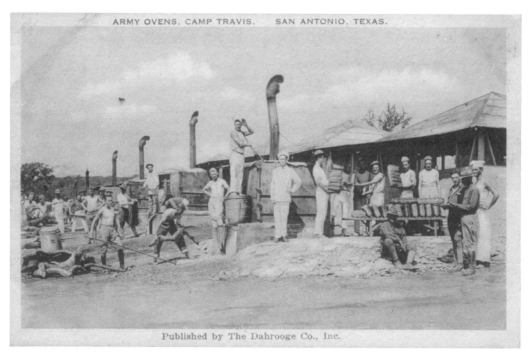

ARMY OVENS. CAMP TRAVIS. SAN ANTONIO, TEXAS.

Published by The Dahrooge Co., Inc.

Using flour from San Antonio's Pioneer Flour Mills, Camp Travis ran eight field ovens that could turn out 6,000 loaves of bread daily. *(Dahrooge Co., San Antonio)*

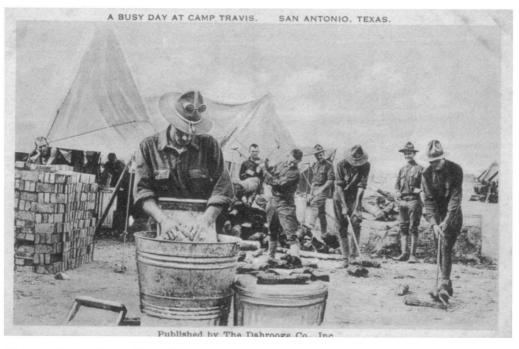

A BUSY DAY AT CAMP TRAVIS. SAN ANTONIO, TEXAS.

Published by The Dahrooge Co., Inc.

"A Busy Day at Camp Travis." *(Albertype Co., Brooklyn, N.Y.)*

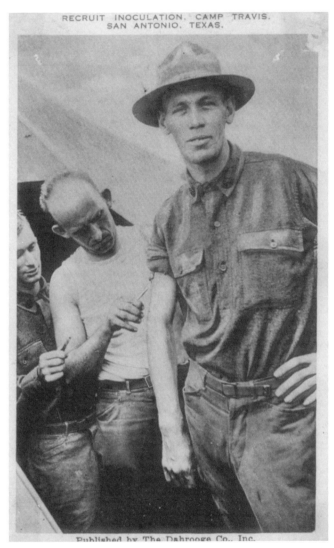

This recruit knew it was better not to look at the needle.
(Albertype Co., Brooklyn)

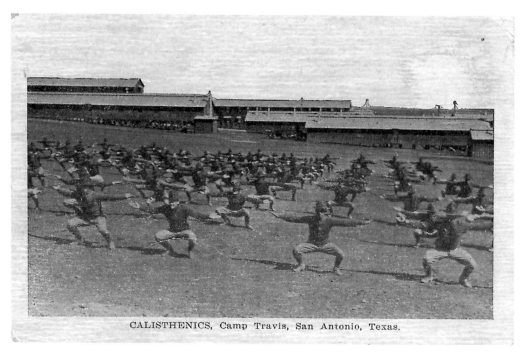

CALISTHENICS, Camp Travis, San Antonio, Texas.

Deep knee bends were in the regimen for trainees. *(A. M. Simon, New York, pm. 1919)*

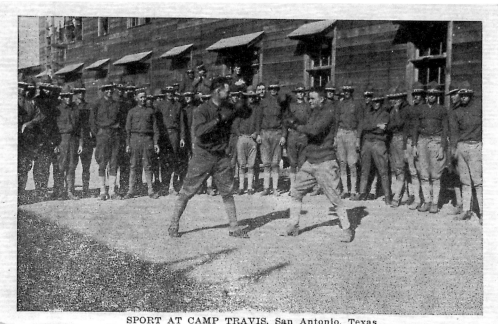

SPORT AT CAMP TRAVIS, San Antonio, Texas.

Spectators gather for a boxing match outside a Camp Travis barracks, its windows equipped with wooden awnings for some protection from the South Texas sun. *(A. M. Simon, New York)*

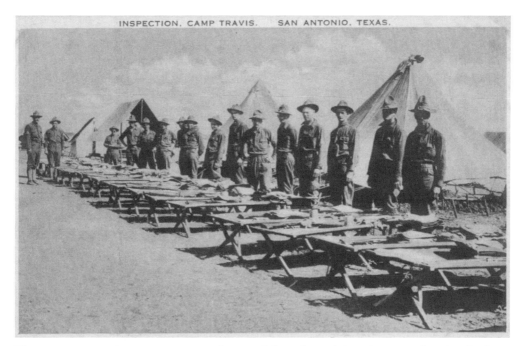

This inspection of recruits apparently was delayed until the photographer finished. *(Dahrooge Co., San Antonio)*

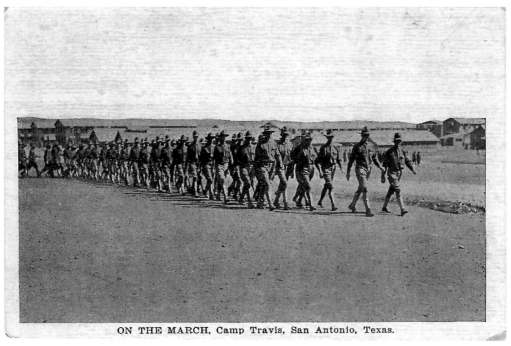

Uniformed, fed and inspected, recruits marched off to the field exercise grounds. *(A. M. Simon, New York)*

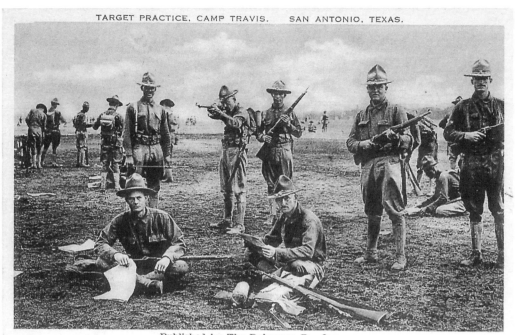

Target practice had its relaxing moments. *(Albertype Co., Brooklyn, N.Y.)*

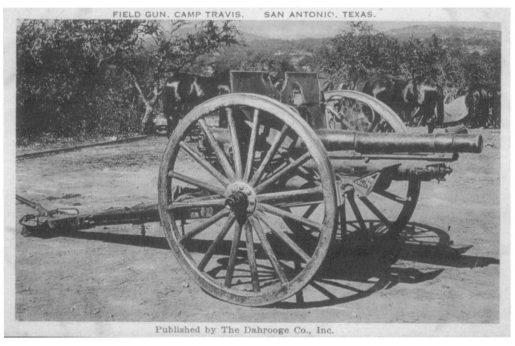

Horses were kept nearby to haul field guns long distances. *(Dahrooge Co., Brooklyn, N.Y.)*

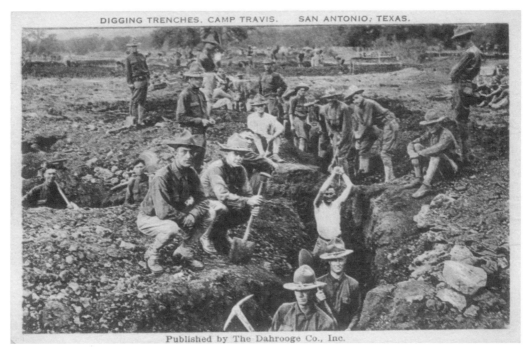

Learning the various configurations of military trenches was important training for what lay ahead in France. *(Dahrooge Co., San Antonio)*

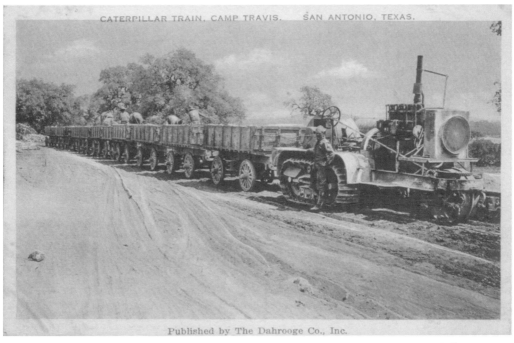

Newly-mechanized warfare included means of hauling heavy loads across difficult terrain. *(Dahrooge Co., San Antonio)*

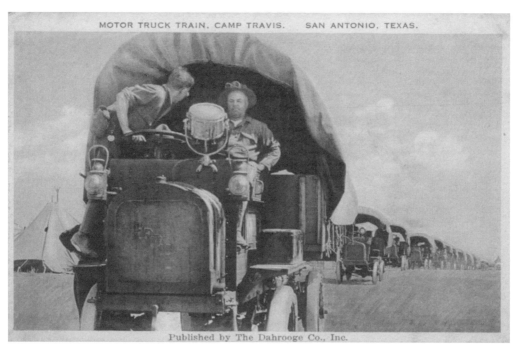

Military trucks at the time worked well on dry ground, but were ill prepared for heavy mud. *(Dahrooge Co., San Antonio)*

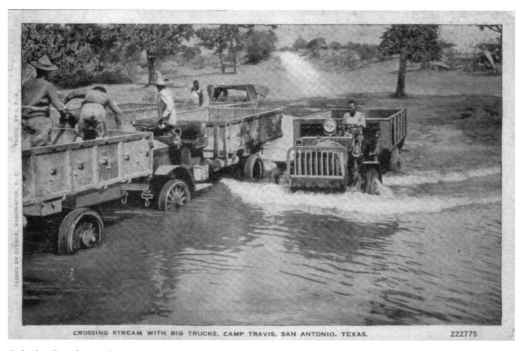

Salado Creek on Camp Travis's eastern border provided valuable training in river crossings. *(Sackett & Williams, New York)*

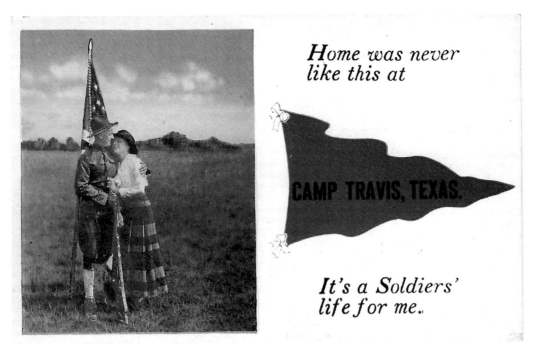

Soldiers could try to make friends back home envious. *(n.p.)*

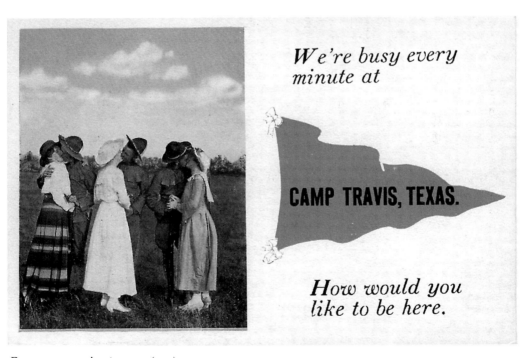

Busy every minute. . . . *(n.p.)*

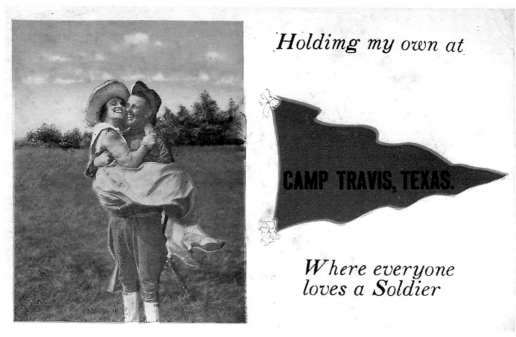

Holding his own. . . . *(n.p.)*

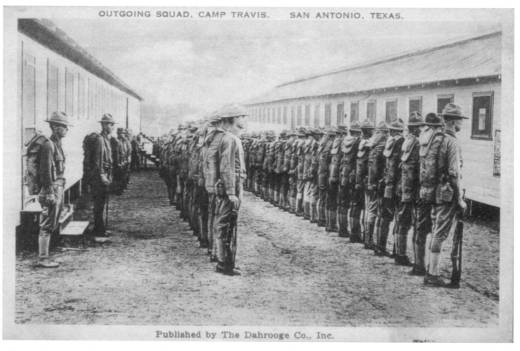

Those leaving Camp Travis looked remarkably different from those who entered.
(Dahrooge Co., San Antonio)

5. Kelly Field and Brooks Field

Aviation Camp opened in 1916 for the Aviation Section of the U. S. Army Signal Corps, previously located at Fort Sam Houston. It was renamed for Lt. George E. Kelly, whose death in a 1911 military plane crash at Fort Sam Houston was the nation's first such pilot fatality. By 1917 Kelly Field was home to 1,100 officers and 31,000 enlisted men. Most World War I aviators earned their wings here as did many later ones, including, in 1925, Lt. Charles Lindbergh.

During World War II, training moved elsewhere as Kelly Field grew into a major maintenance and repair center for fighters, bombers and cargo aircraft. Its million square-foot hangar became the world's largest structure without center columns. The 25,000 military and civilian employees made it the city's largest employer and the nation's oldest continually operating flying base until marked in 1993 for closing. It is being redeveloped as an industrial park complex.

Brooks Field, seven miles southeast of Kelly, was made a pilot training base independent of Kelly in 1918. In 1929 it was the site of the nation's first mass paratroop drop, confirming the viability of paratroop warfare. Pilot training ended in 1945 at Brooks, now best known for its School of Aerospace Medicine.

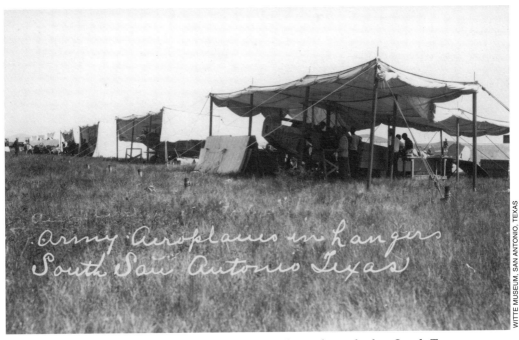

Canvas hangars were hastily erected to protect planes from the hot South Texas sun as the nation's only military flight training got under way at Aviation Camp on April 5, 1917, the day before the United States declared war on Germany. *(n.p.)*

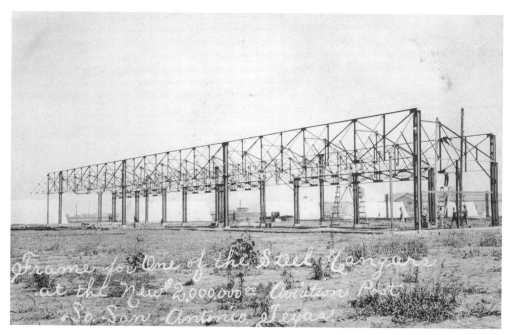

As the war effort intensified, steel hangars began replacing those of canvas. *(n.p.)*

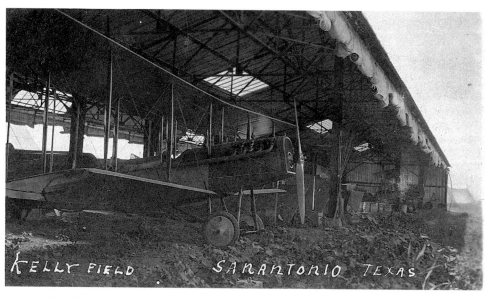

Due to San Antonio's mild climate, unfurled canvas flaps were sufficient to enclose hangars at newly-named Kelly Field for the Curtiss "Jenny." *(n.p., pm. 1917)*

These troops were actually quite content, if you go by the old adage that a soldier is never happy unless he's griping. *(n.p.)*

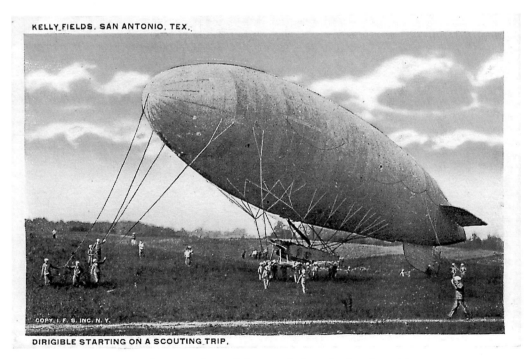

Dirigibles on the ground required careful control. *(S. Rabe, San Antonio)*

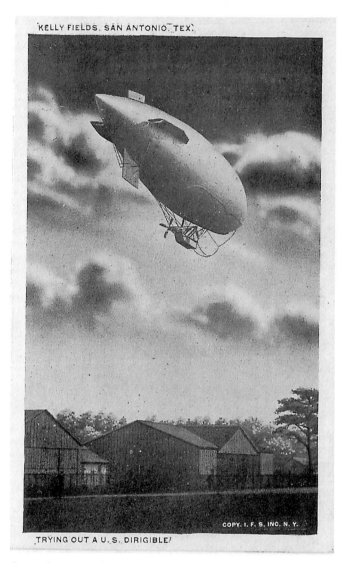

KELLY FIELDS. SAN ANTONIO. TEX.

COPY. I. F. S. INC. N. Y.

TRYING OUT A U. S. DIRIGIBLE?

Soon the Army began experimenting with dirigibles for aerial reconnaissance. *(S. Rabe, San Antonio)*

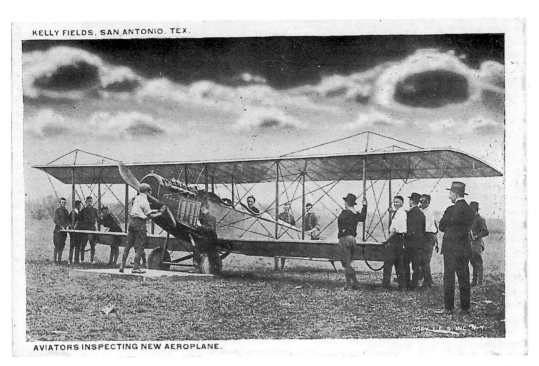

KELLY FIELDS. SAN ANTONIO. TEX.

AVIATORS INSPECTING NEW AEROPLANE.

A crowd inspects a newly-arrived DeHavilland DH-4, a favorite for light bombing and observation squadrons. *(S. Rabe, San Antonio)*

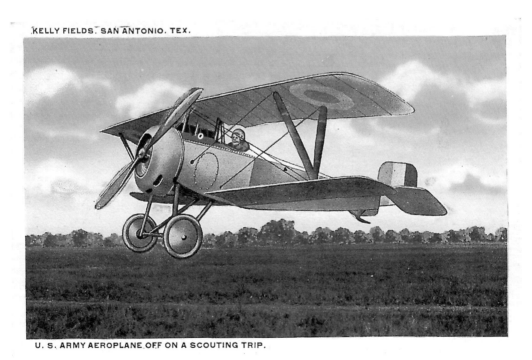

KELLY FIELDS. SAN ANTONIO. TEX.

U. S. ARMY AEROPLANE OFF ON A SCOUTING TRIP.

A practice flight. *(Dahrooge Co., San Antonio)*

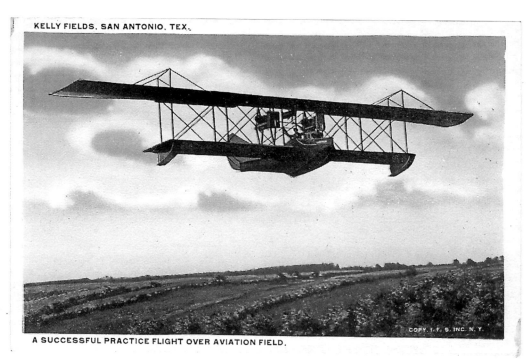

KELLY FIELDS. SAN ANTONIO. TEX.

A SUCCESSFUL PRACTICE FLIGHT OVER AVIATION FIELD.

COPY. I. F. S. INC. N. Y.

Low-level flight restrictions limiting nearby construction have left many fields near Kelly still under cultivation by descendants of the original immigrant Belgian farmers. *(Dahrooge Co., San Antonio)*

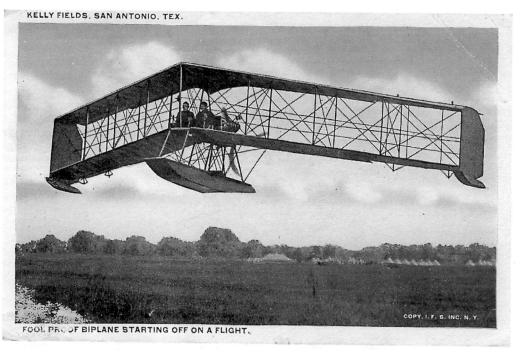

KELLY FIELDS, SAN ANTONIO. TEX.

FOOL PROOF BIPLANE STARTING OFF ON A FLIGHT.

COPY. I. F. S. INC. N. Y.

In case of engine failure, the single wing of this craft would supposedly let this "foolproof" plane glide to a safe landing, with skid attachments to ease the fall. *(Dahrooge Co., San Antonio)*

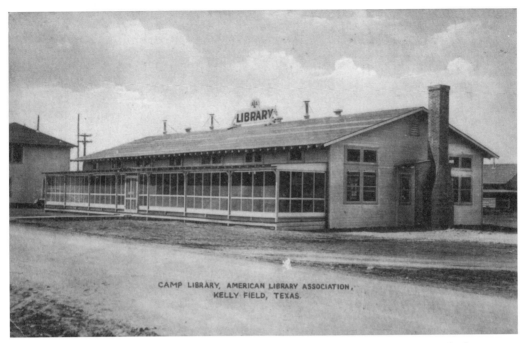

CAMP LIBRARY, AMERICAN LIBRARY ASSOCIATION,
KELLY FIELD, TEXAS.

Soldiers stationed at Kelly Field may have to live in tents, but donors through the American Library Association saw that refinements of civilization were nearby. *(n.p.)*

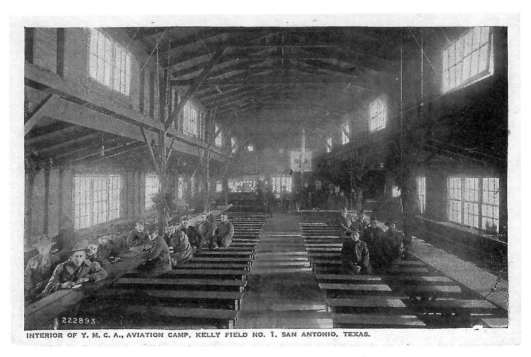

INTERIOR OF Y. M. C. A., AVIATION CAMP, KELLY FIELD NO. 1, SAN ANTONIO, TEXAS.

Another group providing amenities to soldiers was the Y.M.C.A. *(n.p.)*

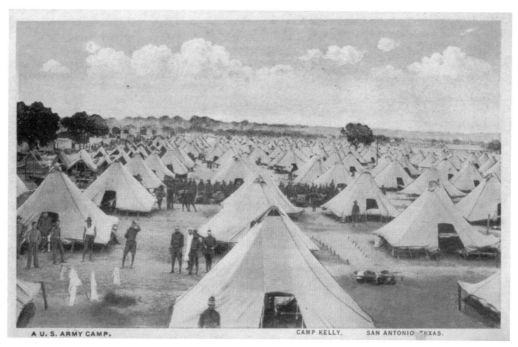

During World War I some 250,000 men got various types of aero squadron training at Kelly Field. Most lived in tents. *(n.p.)*

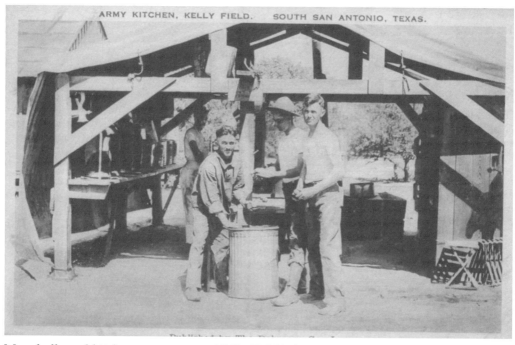

Mess halls and kitchens were among Kelly Field's few wooden structures. *(Dahrooge Co., San Antonio)*

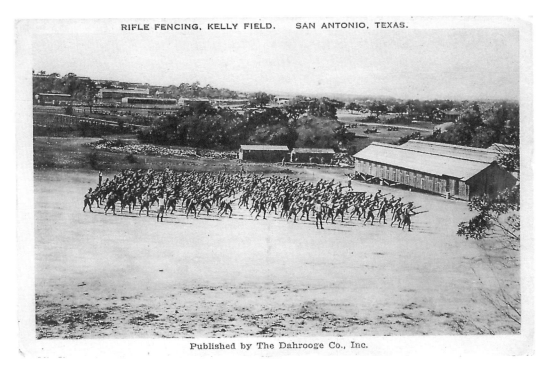

RIFLE FENCING, KELLY FIELD. SAN ANTONIO, TEXAS.

Published by The Dahrooge Co., Inc.

Rifle training included more than target shooting. *(Dahrooge Co., San Antonio)*

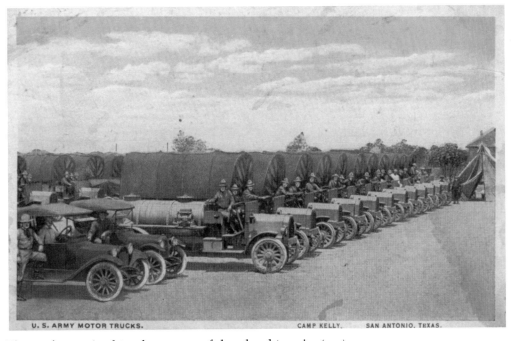

U. S. ARMY MOTOR TRUCKS. CAMP KELLY. SAN ANTONIO, TEXAS.

Fleets of motorized trucks were useful on hard terrain. *(n.p.)*

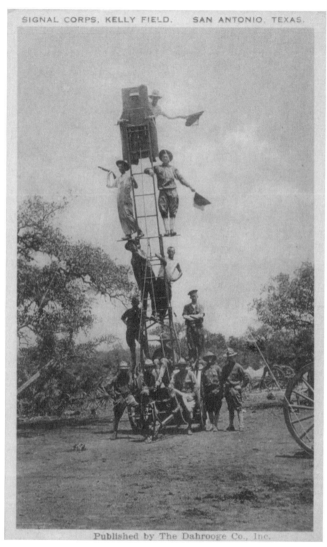

SIGNAL CORPS, KELLY FIELD. SAN ANTONIO, TEXAS.

Published by The Dahrooge Co., Inc.

Absent radio communication, ladders could be used for observation or for sending signals by semaphore, a system of hand-held flags with its own alphabet. *(n.p.)*

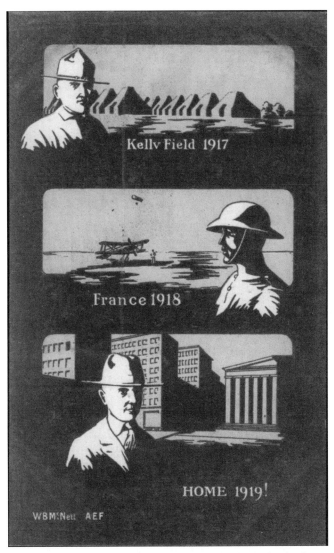

With World War I over, Kelly Field, scrubland which had become the world's largest flying field, was home to only a few hundred military personnel. *(n.p.)*

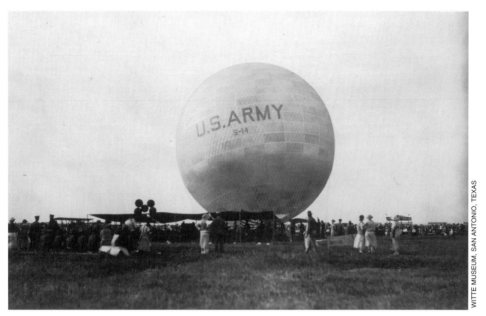

The Army's use of observation balloons dropped sharply after the viability of aircraft was proved in World War I, but in 1924 the Army still made this entry in a highly-publicized national balloon race at Kelly Field. *(n.p.)*

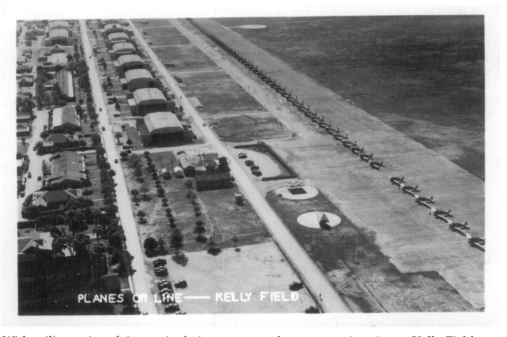

With military aircraft increasingly important and a new war imminent, Kelly Field expanded once more and took on an air of permanence. *(n.p.)*

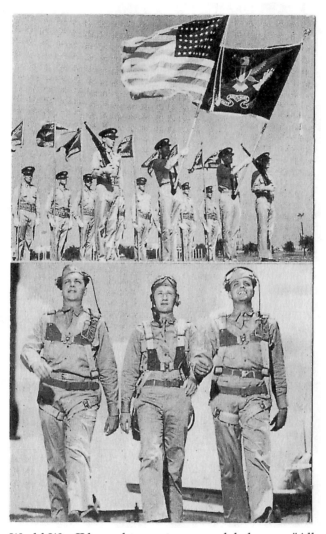

World War II brought new troops and, below, an "All-American Air Crew" of navigation, pilot and bombardier cadets. *(Jumbo Post Card Co., San Antonio)*

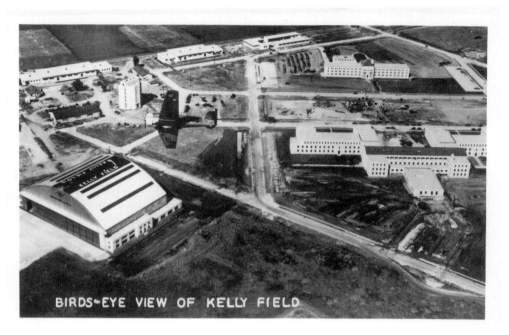

BIRDS-EYE VIEW OF KELLY FIELD

By mid-1940, a federally-funded WPA effort and later projects had added a new operations hangar, permanent quarters and new headquarters and classroom buildings at Kelly Field. *(n.p.)*

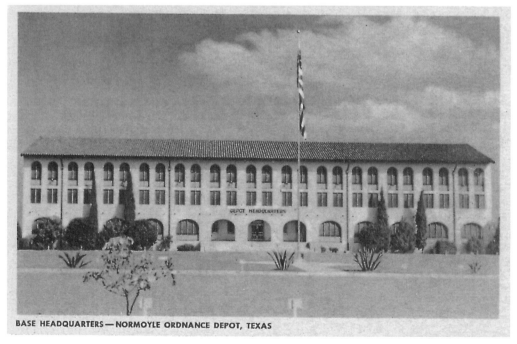

BASE HEADQUARTERS — NORMOYLE ORDNANCE DEPOT, TEXAS

During World War II the Normoyle Ordnance Depot was established at the northeastern corner of Kelly Field. *(Ullman Co., New York)*

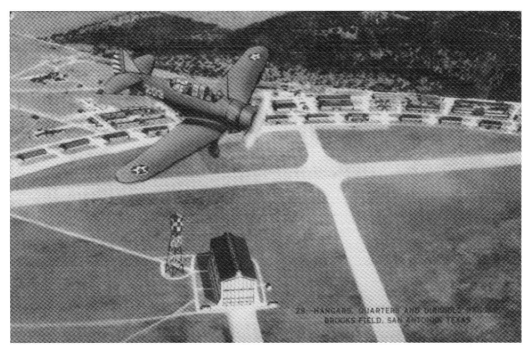

Established in 1917 as the fifth of six fields under the Kelly umbrella, Brooks Field became independent the next year. Its Hangar 9 is the oldest surviving in the Air Force. The dirigible hangar below the plane was built in 1921. *(San Antonio Card Co.)*

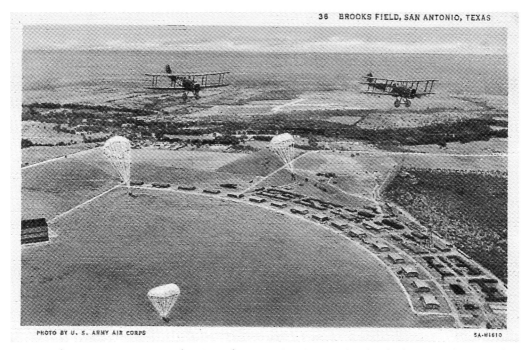

Camp John Wise, a balloon school on the site of today's suburb of Olmos Park, moved to Brooks in 1919. It closed as Brooks became the Army's primary flying school (1922–31). The military's first mass parachute drop was here in 1929. *(Weiner News Co., San Antonio)*

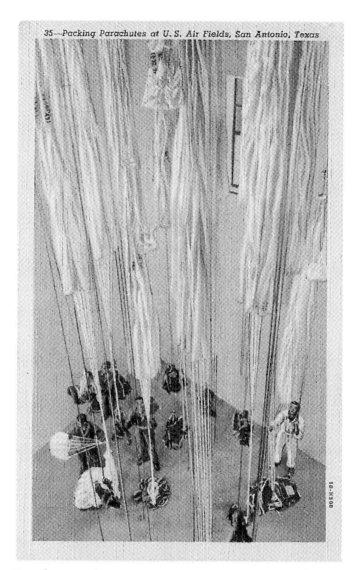

35—Packing Parachutes at U. S. Air Fields, San Antonio, Texas

Parachute packing required a careful sequence so the chutes would open properly when the cord was pulled. *(Weiner News Co., San Antonio)*

6. Randolph Field

With U. S. Army Air Corps flight training requirements outgrowing Kelly and Brooks fields, the 2,300-acre Randolph Field was opened 15 miles northeast of San Antonio in 1930. More than 500 buildings were laid out along 30 miles of roadways, many in a concentric pattern framed by runways on three sides. It was the largest U. S. Army Corps of Engineers project since building of the Panama Canal.

Adding distinctiveness to Randolph is the uniform architectural style of the buildings, the largest complex in the Spanish Colonial Revival style in Texas. Focal point of the entrance is the "Taj Mahal," the headquarters building with a baroque tower that masks the water tank.

Mid level pilot training continued at Randolph Field, known as the "West Point of the Air," until 1939, when training switched to basic pilot training and then, in 1943, to training of flight instructors. In 1957 Air Training Command headquarters moved to Randolph Air Force Base, where it remains along with other headquarters units, including that of the 12th Flying Training Wing for pilot instructors.

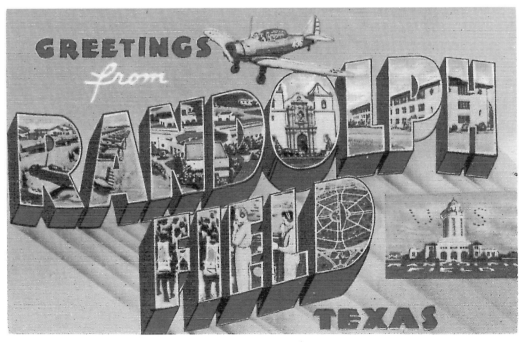

A BT-9, the training plane most used in Randolph Field's early years, soars at the top of this World War II-era greeting card. *(San Antonio Card Co.)*

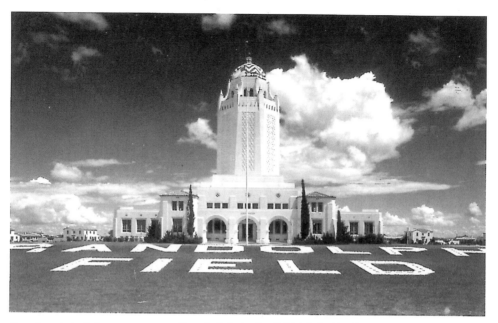

Focal point of the entrance to Randolph is the "Taj Mahal" administration building and a ground-level sign visible from the air. *(n.p.)*

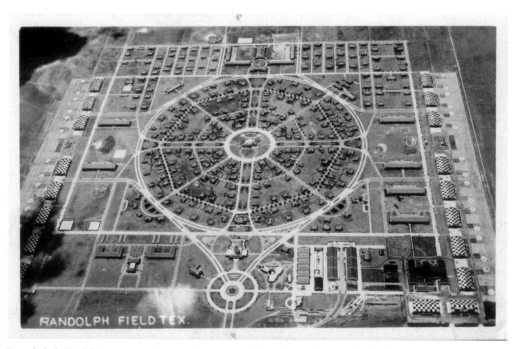

Randolph Field's unique design, by 1st Lt. Harold L. Clark, divided a circle into functional quadrants for primary, basic and advanced flying schools and for a service area. Ramps and runways were built along three sides. *(n.p.)*

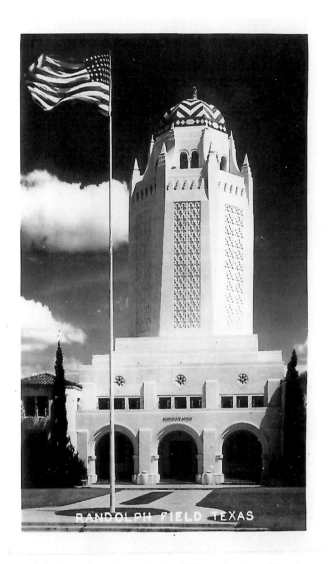

Randolph's administration building, designed by San Antonio architect Atlee B. Ayres, has a distinctive tower concealing a 500,000-gallon water tank. *(n.p.)*

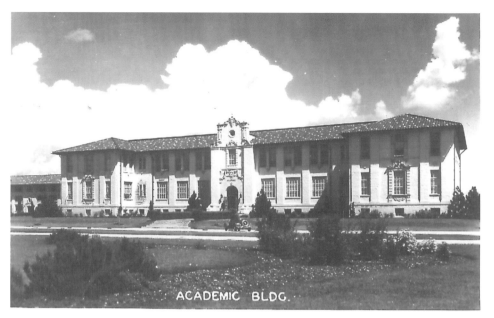

ACADEMIC BLDG.

The Spanish Colonial Revival regional architectural style popular during Randolph Field's construction still adds a distinctive character to the base. *(n.p., pm. 1944)*

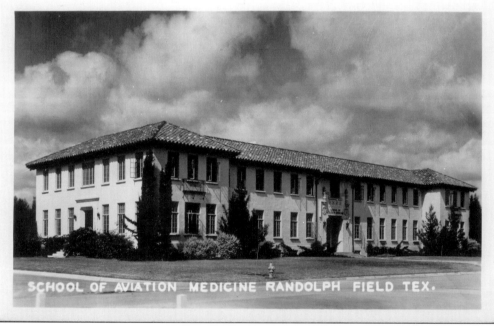

SCHOOL OF AVIATION MEDICINE RANDOLPH FIELD TEX.

The School of Aviation Medicine, an original tenant at Randolph Field, moved to Brooks Air Force Base in 1959. *(n.p.)*

Basic aviation cadet training continued at Randolph Field until it was replaced in 1943 with the Central Instructors' School. *(n.p.)*

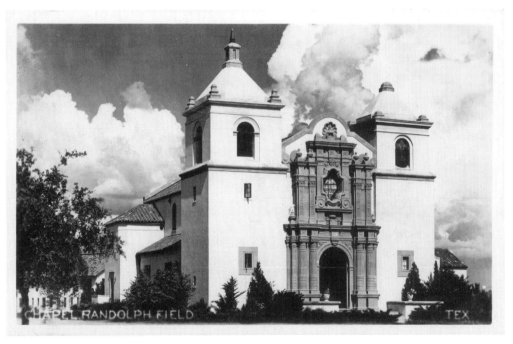

The chapel's twin towers resemble those of San Antonio's Mission Concepción, though the entrance is in the more elaborate Baroque style of Mission San José's. *(n.p.)*

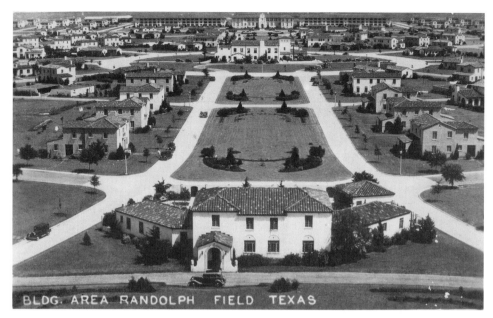

BLDG. AREA RANDOLPH FIELD TEXAS

The view from the "Taj Mahal" shows no trace of the land's original 17 farm houses, removed when the harvest was completed in October 1928 and military construction began. *(n.p., pm. 1943)*

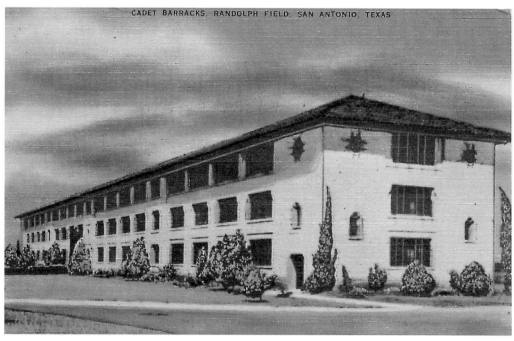

CADET BARRACKS, RANDOLPH FIELD, SAN ANTONIO, TEXAS

Unlike the earlier hasty wartime frame construction at San Antonio military bases, the barracks at Randolph Field had the advantage of solid construction after careful planning. They are built of local hollow clay tile. *(San Antonio Card Co.)*

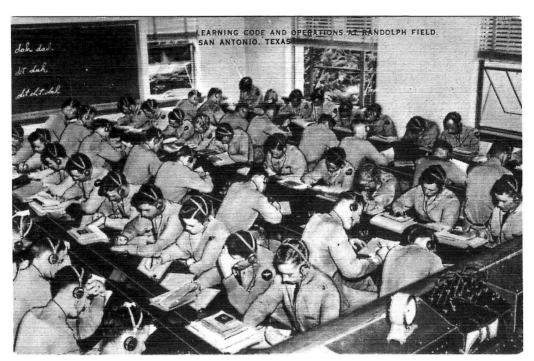

Classroom work included intensive lessons in Morse Code. *(San Antonio Card Co.)*

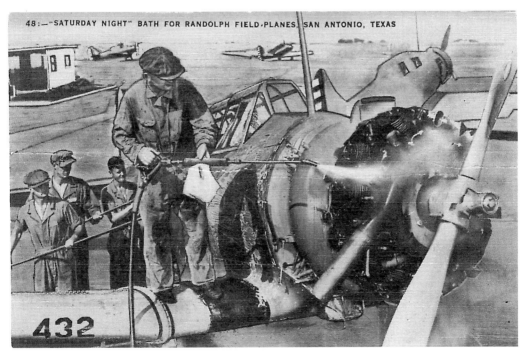

Periodic maintenance was conducted on BT-9 trainers. *(San Antonio Card Co.)*

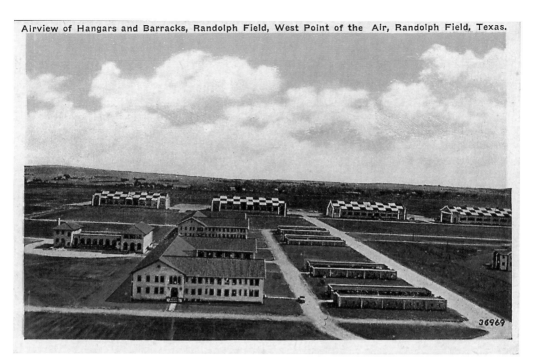

Level, unobstructed farmland stretched in every direction from Randolph Field. *(Hewitt Post Card Co., San Antonio)*

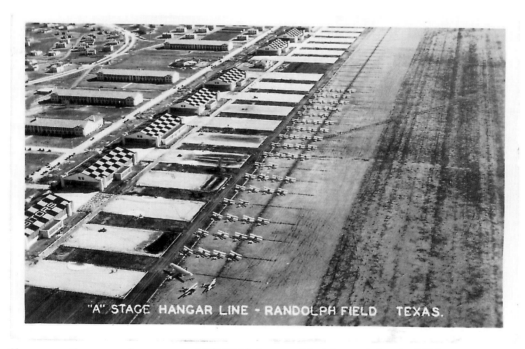

"A" STAGE HANGAR LINE - RANDOLPH FIELD TEXAS.

Shown on the ground are rows of PT-13 biplanes added for training in 1936. *(n.p.)*

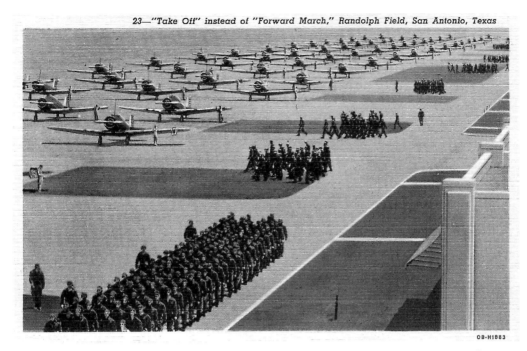

OB-H1883

Training at Randolph Field increased sharply in 1939, when the Army Air Corps began to double active duty pilots to 4,500. Soon the goal went to 12,000 new pilots per year, then more, and new training fields were built elsewhere. *(Weiner News Co., San Antonio)*

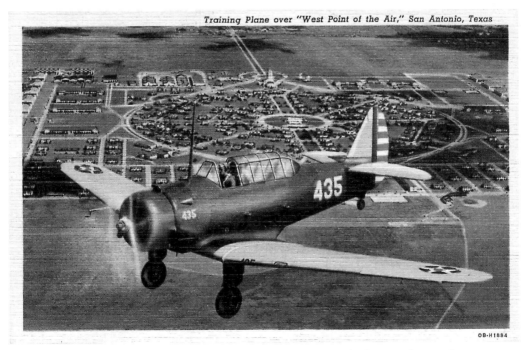

Training Plane over "West Point of the Air," San Antonio, Texas

OB-H1884

BT-9s had a retractable landing gear and a maximum speed of 170 miles per hour. *(Weiner News Co., San Antonio)*

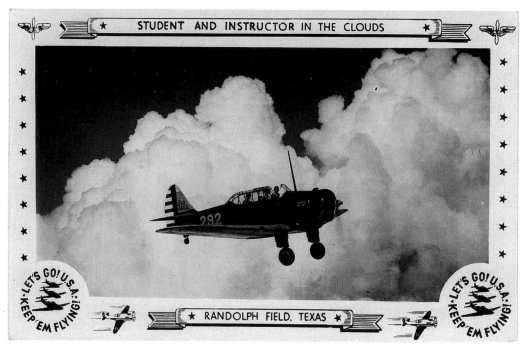

Flight instructors flew behind student pilots in the BT-9's rear seat about 40 percent of the time. *(n.p.)*

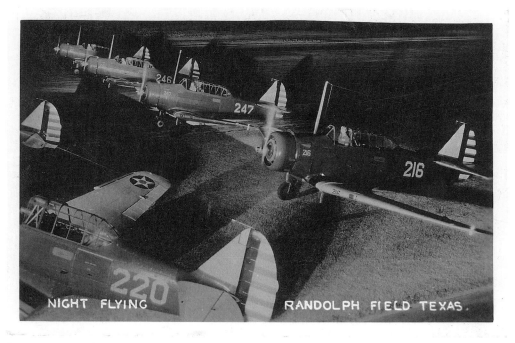

San Antonio's flying weather was ideal for flight training day and night. *(n.p., pm. 1942)*

7. San Antonio Aviation Cadet Center/Lackland Air Force Base

When World War II caused Kelly Field to become a major maintenance and supply center and training functions were moved elsewhere, in mid-1942 some 3,500 acres of higher ground west of Leon Creek were formally separated from Kelly to become the independent San Antonio Aviation Cadet Center.

At first known as "Kelly on the Hill," the Aviation Cadet Center provided preflight training for pilots, bombardiers, navigators and support personnel in the Army Air Corps. Although it had no runway, in 1946 it was renamed Lackland Army Air Field after a former Kelly commander who had the idea for the center. Two years later, with creation of the Air Force as a separate service, it became Lackland Air Force Base.

Since known as the "Gateway to the Air Force," Lackland is the Air Force's sole basic training center for enlistees and at times has hosted officer training as well. It also houses the Defense Language Institute English Language Center and Wilford Hall Medical Center, the Air Force's largest medical facility.

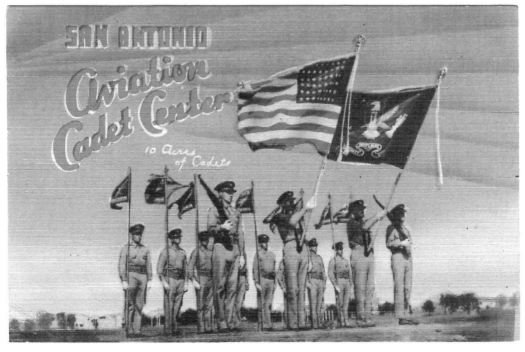

"10 Acres of Cadets" identified the center where more than 90,000 candidates for flying training came during World War II. (*San Antonio Card Co., pm. 1945*)

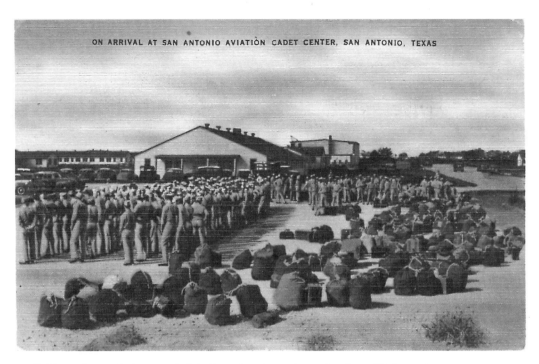

ON ARRIVAL AT SAN ANTONIO AVIATION CADET CENTER, SAN ANTONIO, TEXAS

Duffel bags littered the area behind ranks of newly-arrived preflight trainees. *(San Antonio Card Co.)*

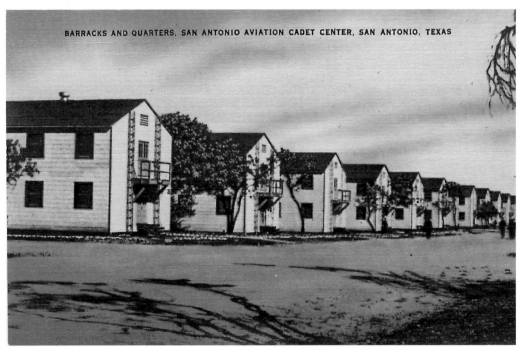

BARRACKS AND QUARTERS, SAN ANTONIO AVIATION CADET CENTER, SAN ANTONIO, TEXAS

Most barracks built for World War II trainees remained in use for more than twenty years. *(San Antonio Card Co.)*

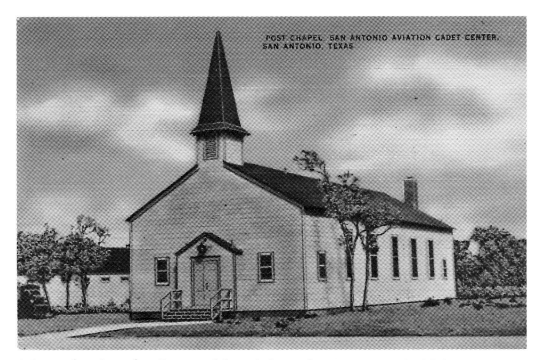

A frame chapel was hastily erected for aviation cadets. *(San Antonio Card Co.)*

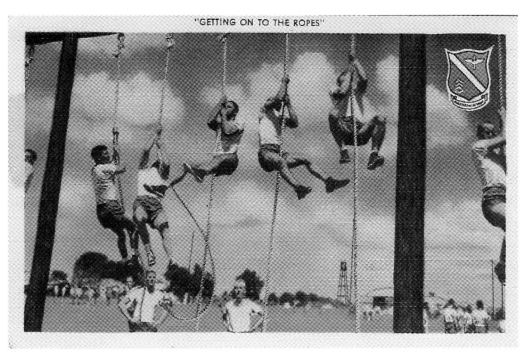

Scaling ropes was part of cadets' physical fitness regimen. *(San Antonio Aviation Cadet Center)*

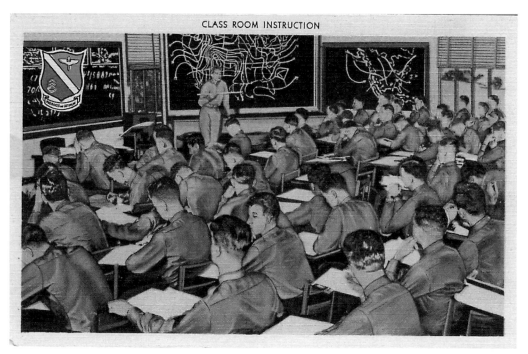

Classroom subjects included aircraft recognition, map reading, math and physics. *(San Antonio Aviation Cadet Center)*

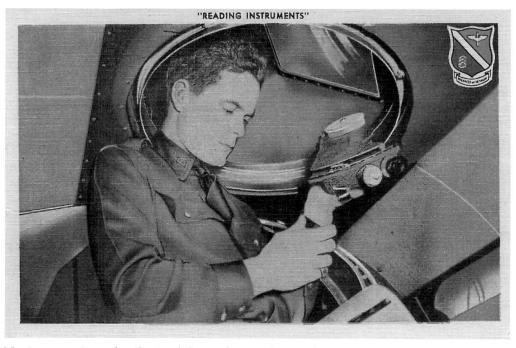

Navigator trainees familiarized themselves with actual instruments. *(San Antonio Aviation Cadet Center)*

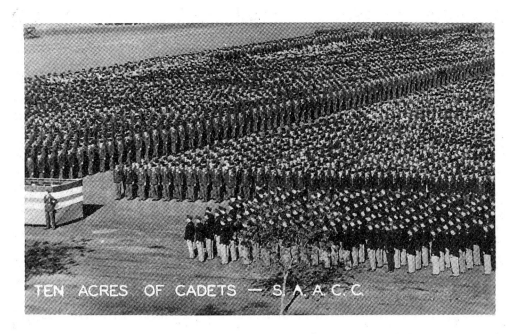

The San Antonio Aviation Cadet Center advertised that its assembled cadets covered ten acres. *(n.p., pm. 1943)*

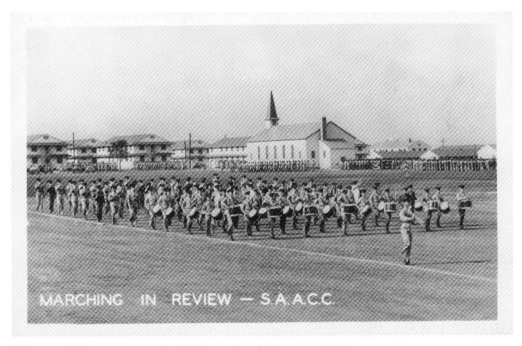

A large training center merited a large band. *(n.p., pm. 1943)*

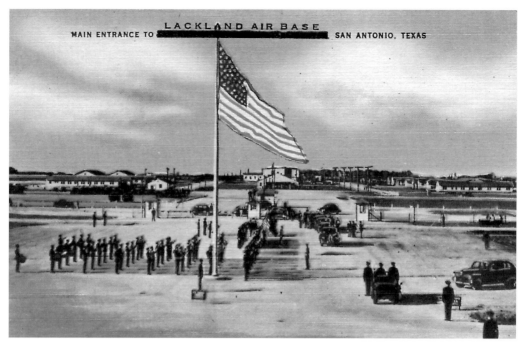

A turning point is symbolized by the postcard manufacturer's blacking out "San Antonio Aviation Cadet Center" and placing above it the new name, Lackland Air Base. *(San Antonio Card Co.)*

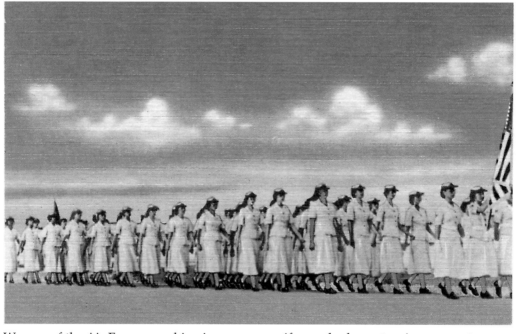

Women of the Air Force, marching in summer uniforms, had quarters in a separate area of the new Lackland Air Force Base. *(n.p.)*

8. Military Academies

The strong military presence in San Antonio encouraged an unusually large number of junior and senior high school level military academies. All had boarding facilities. Of the half dozen military academies in the city in the early part of the twentieth century, two survive.

The college preparatory Texas Military Institute was established near Fort Sam Houston in 1893 as West Texas Military Academy. Its students there included Douglas MacArthur, son of the post commander. It changed its name and moved to Alamo Heights in 1910 and to northwestern San Antonio in 1989. From 1926 to 1954 TMI was allied with San Antonio Academy, founded in 1886 and since 1967 teaching pre-kindergarten through eighth grades on a campus two miles north of downtown.

The third enduring military academy was Peacock, for boys between ages 12 and 18, which opened beside Woodlawn Lake in western San Antonio in 1894 and closed there in 1973. In 1915 Lt. Dwight D. Eisenhower, stationed at Fort Sam Houston, coached football at Peacock Military Academy. His future wife, Mamie, attended even his practice games.

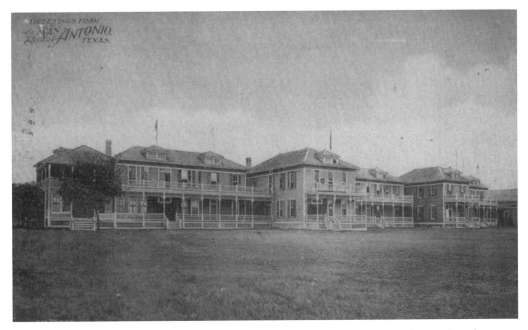

West Texas Military Academy, later Texas Military Institute, was first located in these frame buildings on Grayson Street near Fort Sam Houston. *(Nic Tengg, San Antonio, pm. 1909)*

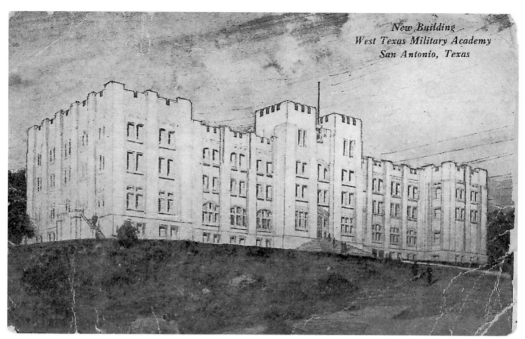

New Building
West Texas Military Academy
San Antonio, Texas

In 1912 Texas Military changed its name and moved to the suburbs. Its new building was this pioneering precast, tilt-up structure designed by architect J. Flood Walker near a bluff at the end of College Boulevard in Alamo Heights. *(n.p.)*

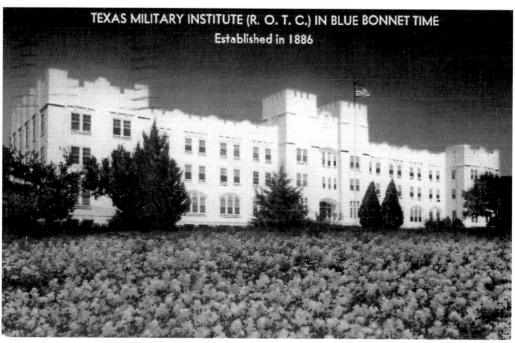

TEXAS MILITARY INSTITUTE (R. O. T. C.) IN BLUE BONNET TIME
Established in 1886

"Old Main" stood until TMI moved to northwestern San Antonio in 1989, having outlasted former San Antonio Superintendent of Schools Charles J. Lukin's nearby Lukin Military Academy, open on Broadway in Alamo Heights from 1917 to 1930. *(n.p., pm. 1944)*

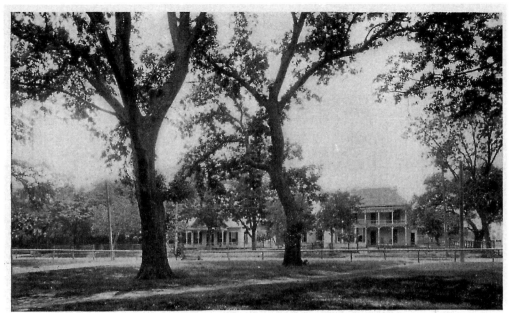

SAN ANTONIO ACADEMY, SAN ANTONIO, TEX.

San Antonio Academy, established by Dr. William B. Seeley on East Houston Street in 1886, moved two years later to these buildings facing San Pedro Park and on to East French Place in 1967. Like TMI, the school is now coeducational. *(n.p.)*

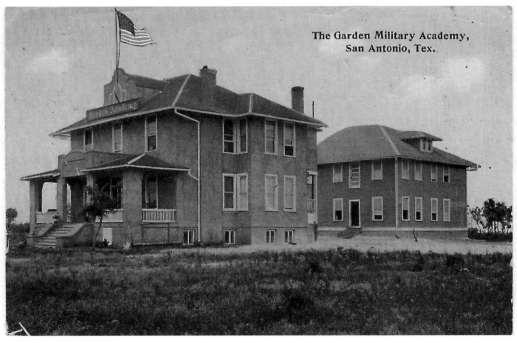

The Garden Military Academy, San Antonio, Tex.

The young Garden Military Academy, run by the Rev. Alfred W. S. Garden, an Episcopalian, moved about 1912 from Maverick Park to these buildings near Highland Park in southeastern San Antonio and closed about 1916. *(H. Budow, San Antonio, pm. 1918)*

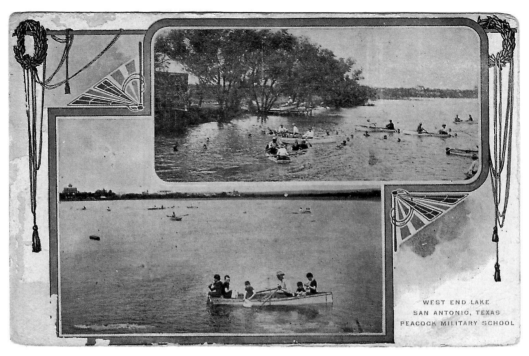

West End Lake
San Antonio, Texas
Peacock Military School

Wesley Peacock's Peacock Military Academy promoted its location on West End Lake, now Woodlawn Lake, as an idyllic setting for a boys' military school. *(n.p.)*

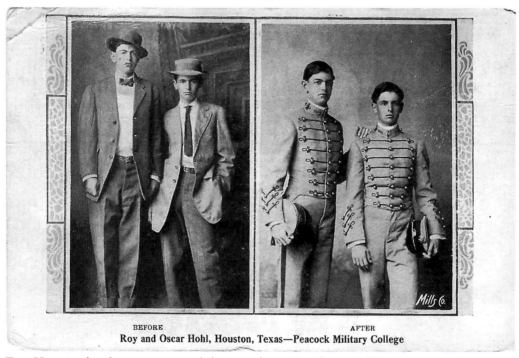

BEFORE

AFTER

Roy and Oscar Hohl, Houston, Texas—Peacock Military College

Two Houston brothers represented the transformation from civilian teenagers to academy cadets. *(n.p., pm. 1910)*

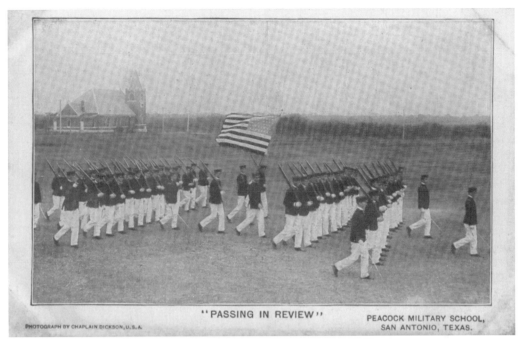

"PASSING IN REVIEW"

PHOTOGRAPH BY CHAPLAIN DICKSON, U.S.A.

PEACOCK MILITARY SCHOOL,
SAN ANTONIO, TEXAS.

Peacock cadets pass in review on the 15-acre campus. *(n.p.)*

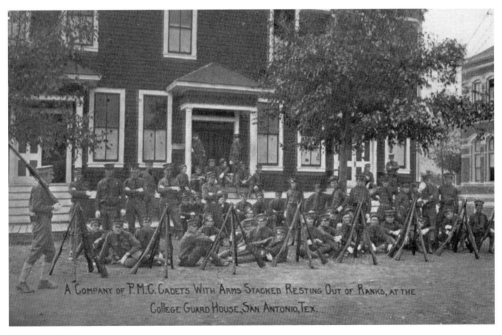

A Company of P.M.C. Cadets With Arms Stacked Resting Out of Ranks, at the College Guard House, San Antonio, Tex.

Peacock cadets kept close to their arms while resting. *(Dahrooge Co., San Antonio)*

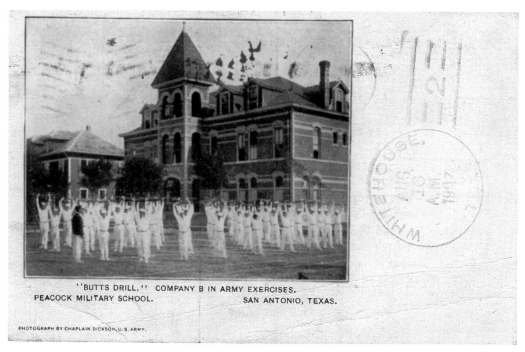

"BUTTS DRILL." COMPANY B IN ARMY EXERCISES.
PEACOCK MILITARY SCHOOL. SAN ANTONIO, TEXAS.

PHOTOGRAPH BY CHAPLAIN DICKSON, U.S. ARMY.

Cadets drill in front of Johnston Hall, built in 1899. *(n.p., pm. 1907)*

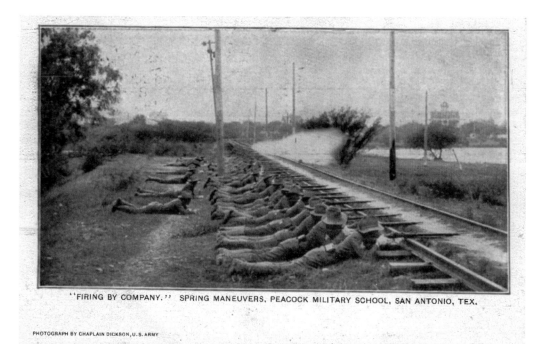

"FIRING BY COMPANY." SPRING MANEUVERS. PEACOCK MILITARY SCHOOL, SAN ANTONIO, TEX.

PHOTOGRAPH BY CHAPLAIN DICKSON, U.S. ARMY

Peacock, a heavy user of promotional postcards, used this one to announce on the reverse that a just-retired Army colonel new to the faculty gave the academy "the highest ranking officer of all the military schools in the south." *(n.p., pm. 1907)*

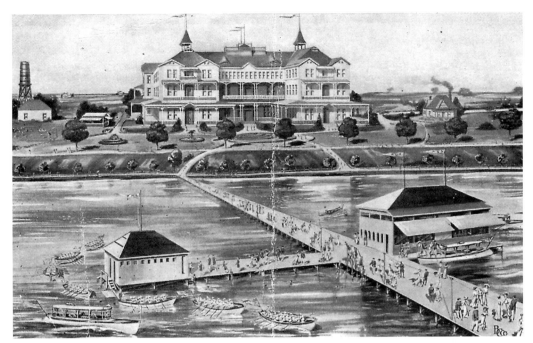

In 1911 Peacock tried expanding on its lakeside ambiance by turning Corpus Christi's old Alta Vista Hotel on the Texas coast into the summertime Peacock Naval School. But costs were high and the hotel was isolated, and the experiment was not repeated. *(n.p.)*

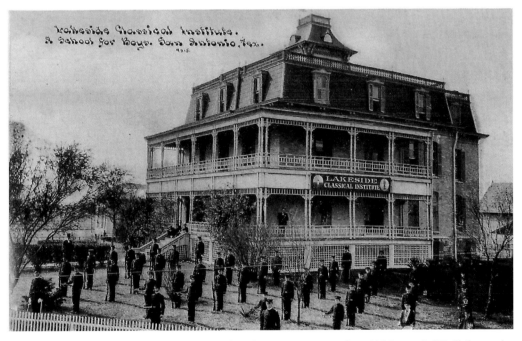

Peacock's neighbor on West End Lake for about six years after 1906 was J. W. Coltrane's Lakeside Classical Institute, which instilled its students with a sense of military discipline. *(Sam Rosenthall, San Antonio)*

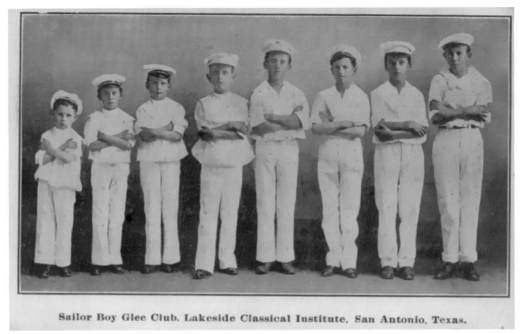

Sailor Boy Glee Club, Lakeside Classical Institute, San Antonio, Texas.

Lakeside's location on West End Lake lent a natural nautical theme for the school's Glee Club. *(n.p., pm. 1908)*

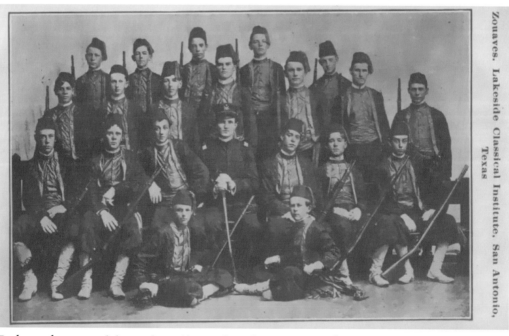

Zouaves, Lakeside Classical Institute, San Antonio, Texas

Perhaps the most elaborately uniformed student group in the city was Lakeside's Zouaves. *(n.p.)*

Bibliography

Bilstein, Roger, and Jay Miller. *Aviation in Texas.* Austin: Texas Monthly Press, 1985.

Cagle, Eldon, Jr. *Quadrangle: The History of Fort Sam Houston.* Austin: Eakin Press, 1985.

Cordova, Raymond S., and Arnoldo Rodriguez. *Kelly Air Force Base Golden Anniversary 1917–1967.* San Antonio: San Antonio Air Materiel Area, 1967.

Hussey, Ann, et al., *A History of Military Aviation in San Antonio.* San Antonio: n.p., 1997.

Johns, E. B., comp. *Camp Travis and Its Part in the World War.* New York: Wynkoop, Hallenbeck, Crawford Co., 1919.

Miller, George, and Dorothy Miller. *Picture Postcards in the United States 1893–1918.* New York: Clarkson N. Potter, 1976.

Peacock, Donna. *Parade Rest, Book One: Peacock Military Academy 1894–1941.* San Antonio: Burke Publishing Company, 1990.

Turner, Leo. *The Story of Fort Sam Houston 1876–1936.* San Antonio, n.p., 1936.

Tyler, Ron, ed. *The New Handbook of Texas.* 6 vols. Austin: The Texas State Historical Association, 1996.

Vanderwood, Paul J., and Frank N. Samponaro. *Border Fury, A Picture Postcard Record of Mexico's Revolution and U. S. War Preparedness, 1910–1917.* Albuquerque: University of New Mexico Press, 1988.